BRAVEST

YORK CITY THANKS YOU

COURAGE AND YOUR BR

UR TIME OF NEED, AN

YOU RISK YOUR LIFE F

BRAVERY RESEMBLES

NG IN THE EYES OF

TMS TO DEVASTATIO

LL IN THE LINE

ORK CITY'S BRAVEST

OWN AS NEW YORK

ANGELS

Lamentation 9/11

Text by **E. L. DOCTOROW**
Preface by **KOFI ANNAN**
Photographs by **DAVID FINN**

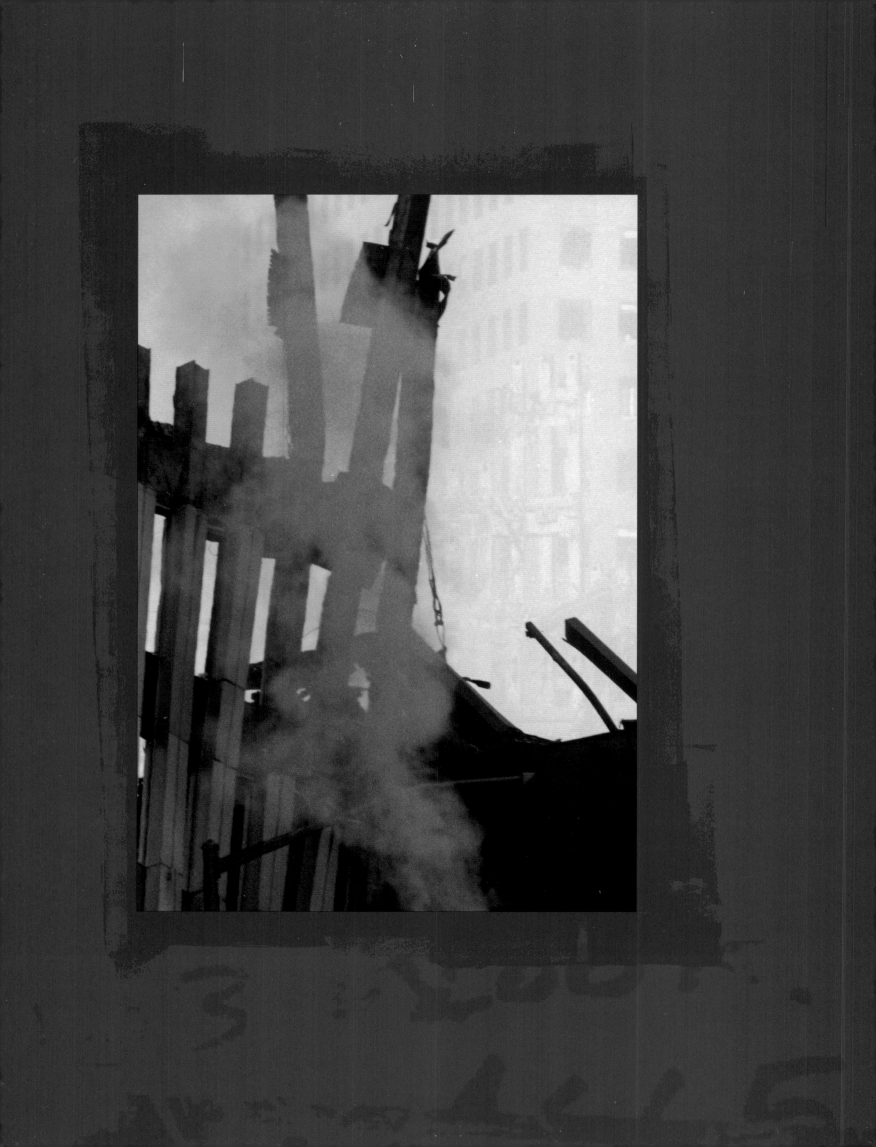

The vicious acts that were perpetrated on 11 September were an attack on humanity itself. New York was struck by a blow so deliberate, malicious and destructive, that we are still struggling to grasp its significance. We were astonished by the evil in our midst and dazed by the disregard for human life. Our souls were shaken.

On that day, the United Nations grieved with other New Yorkers at the gaping wound that had been inflicted on this wonderful city — this city that has been such a warm and welcoming host to us for five decades. We felt a deep bond of solidarity with all Americans in our shared hour of trial

We mourned the deaths of so many valiant fire fighters, police officers and other emergency workers who lost their lives in the tragedy and in the rescue and recovery efforts — people to whom we in the UN owe a special debt of gratitude for their work to keep us safe over the years. We mourned the deaths of people from many of our Member States, in addition to those of the Americans who perished. We mourned an attack on our shared values.

Terrorism strikes at the very heart of everything the United Nations stands for. It presents a global threat to democracy, the rule of law, human

rights and stability. All nations of the world must renew efforts to eradicate terrorism from the face of the earth.

After a season of savage loss, let us now sustain our resolve to unite against the forces of darkness and rededicate ourselves to the cause of peace. Let us reassert the freedom of people from every faith, culture and nation to meet, mingle and exchange ideas and knowledge in mutual respect and tolerance — the very freedom that New York City symbolizes, more than any other city in the world.

KOFI ANNAN

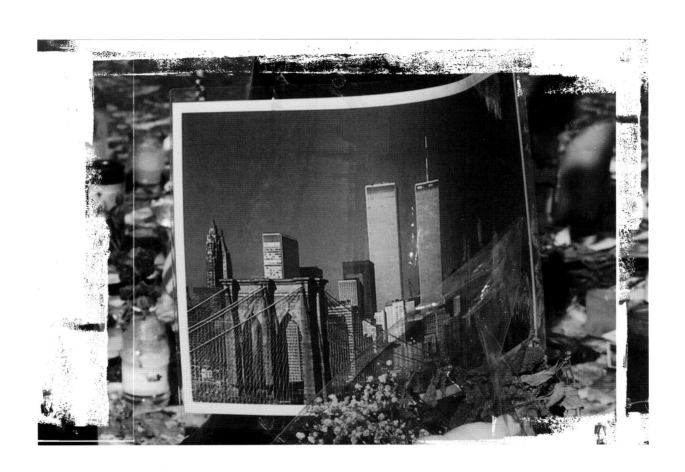

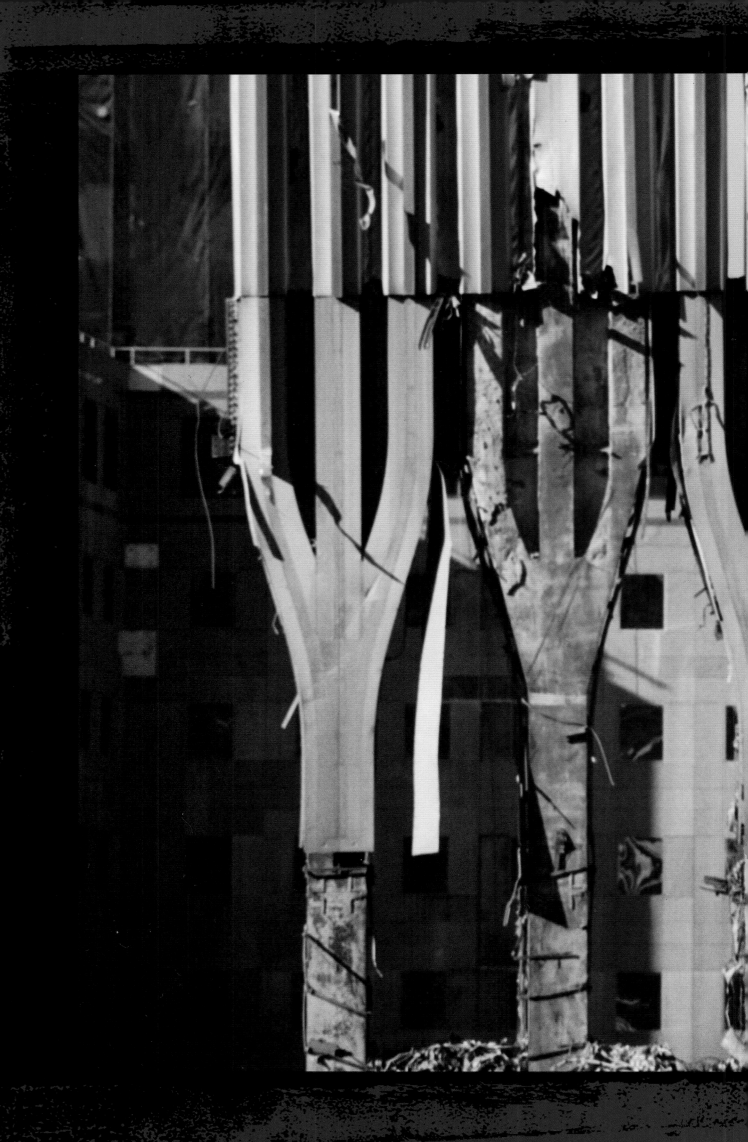

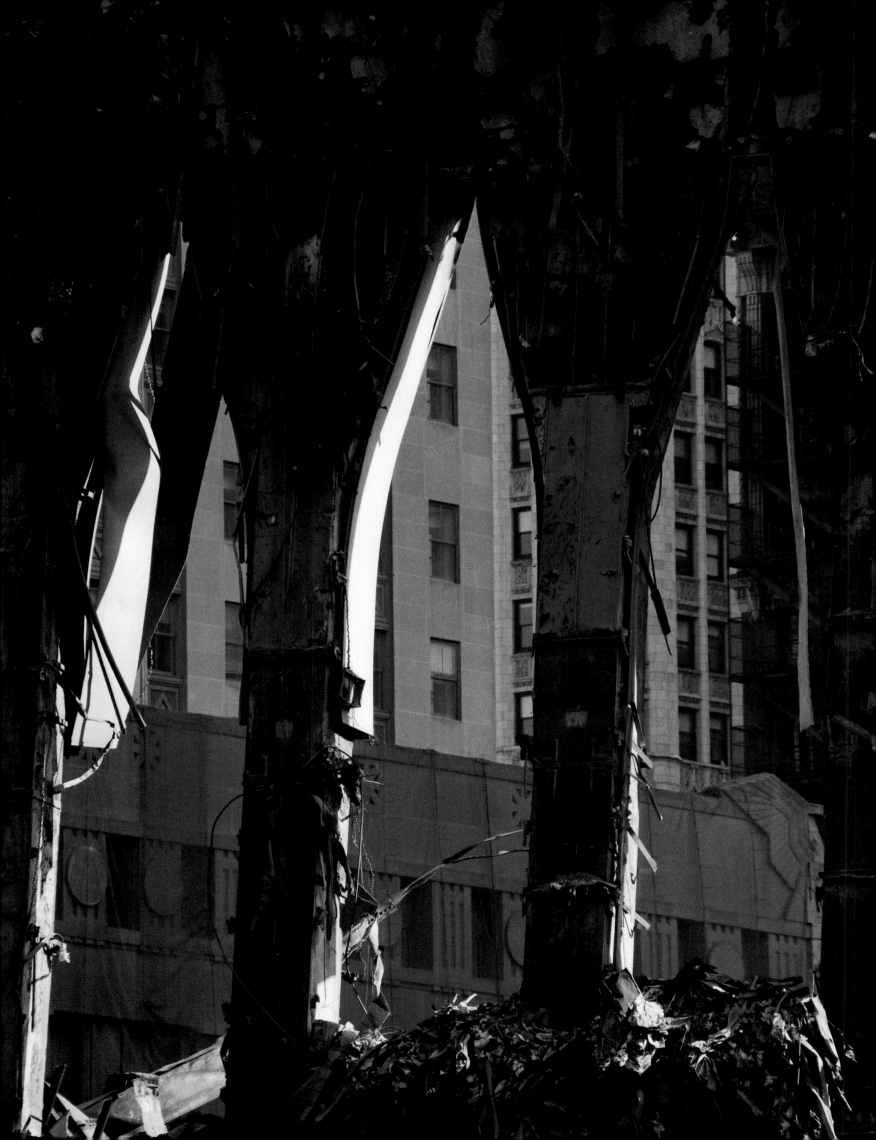

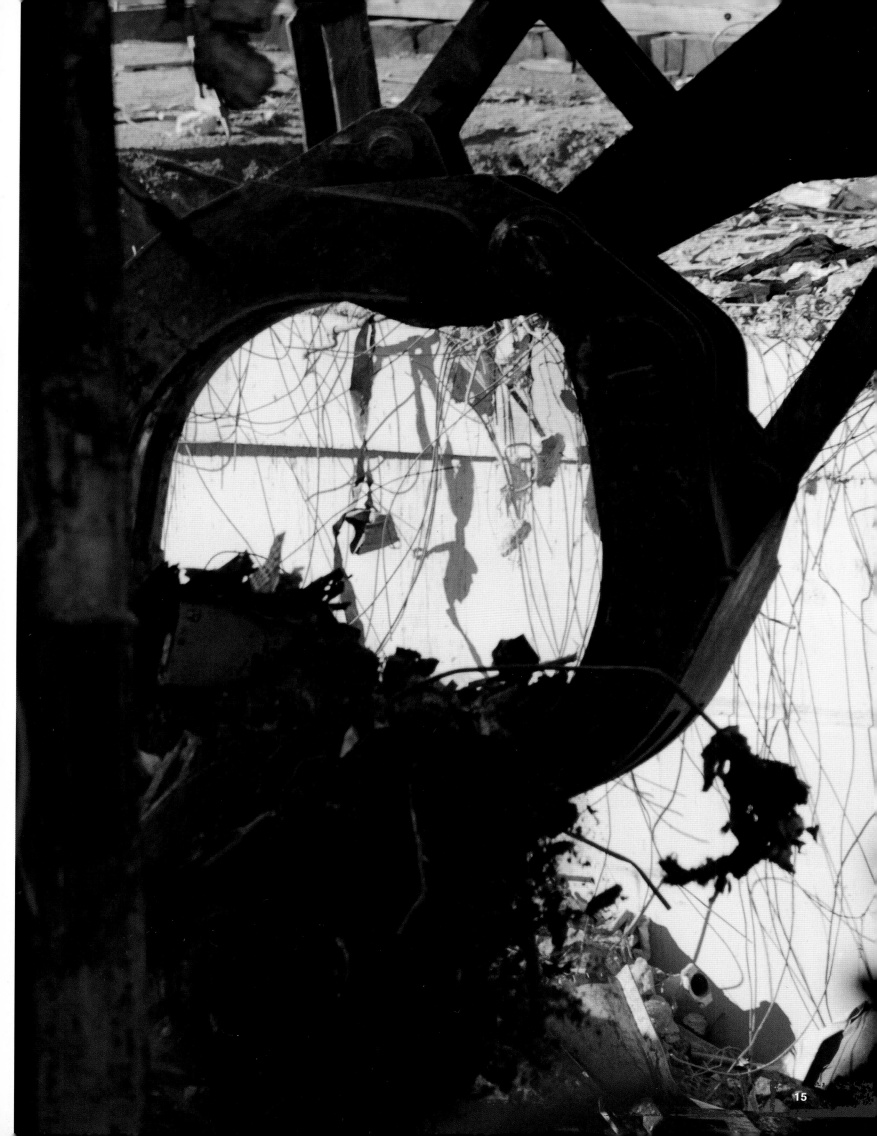

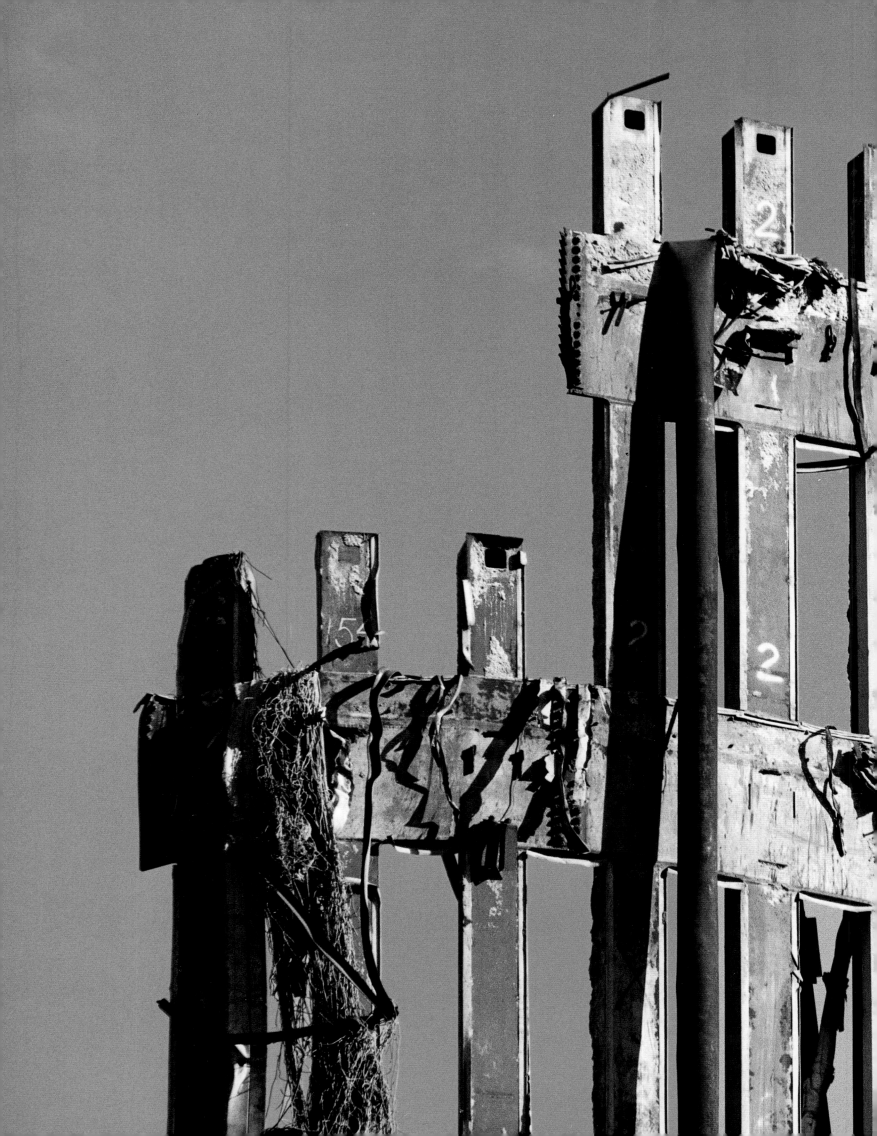

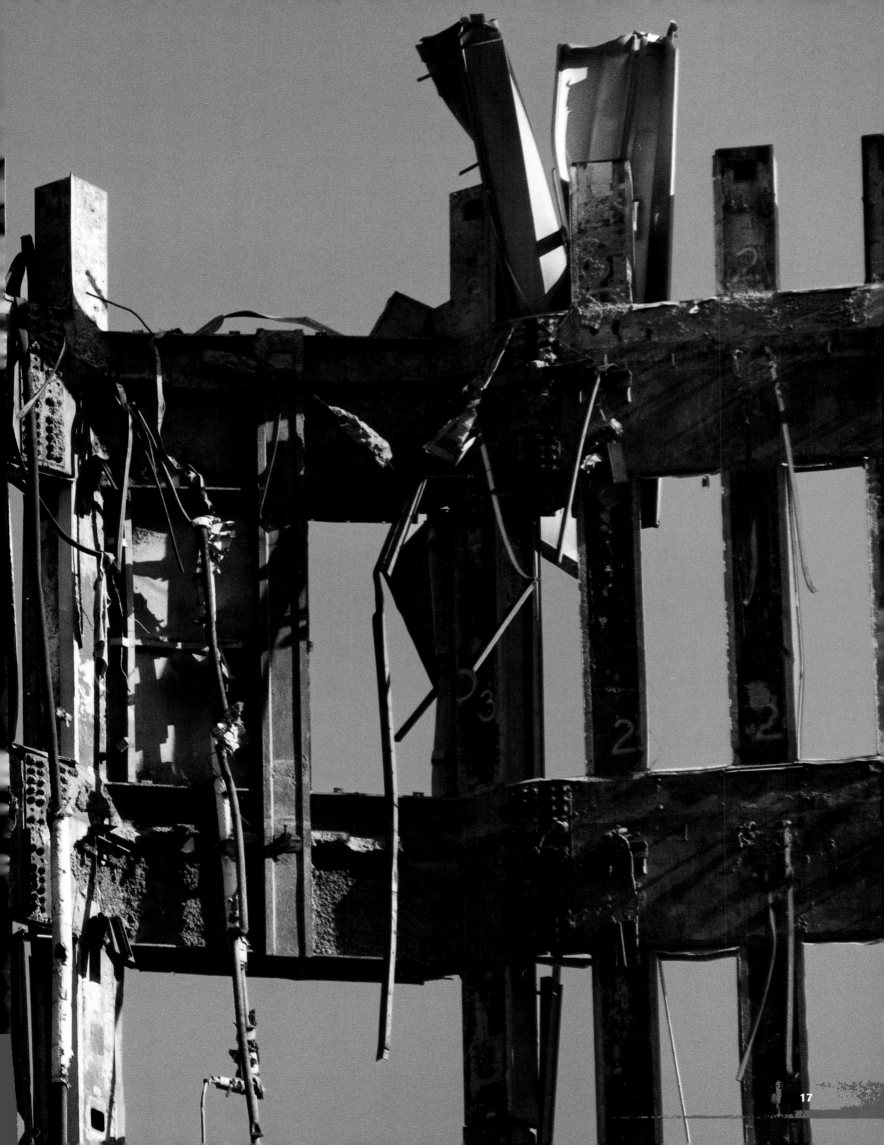

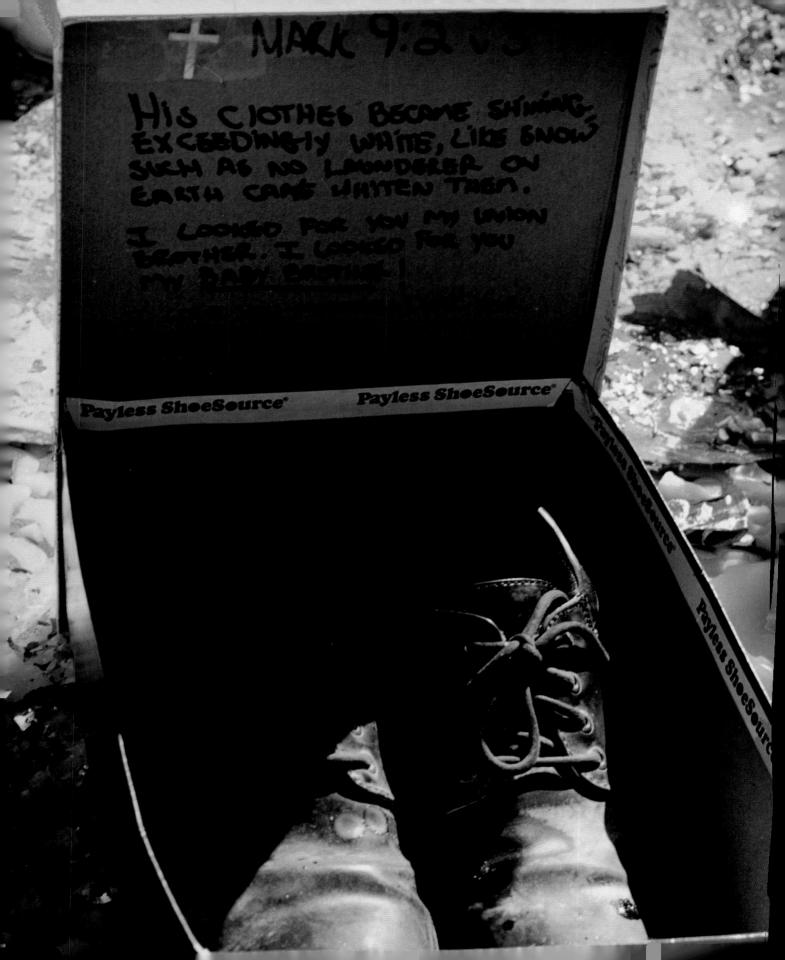

I didn't know them, the people who died there

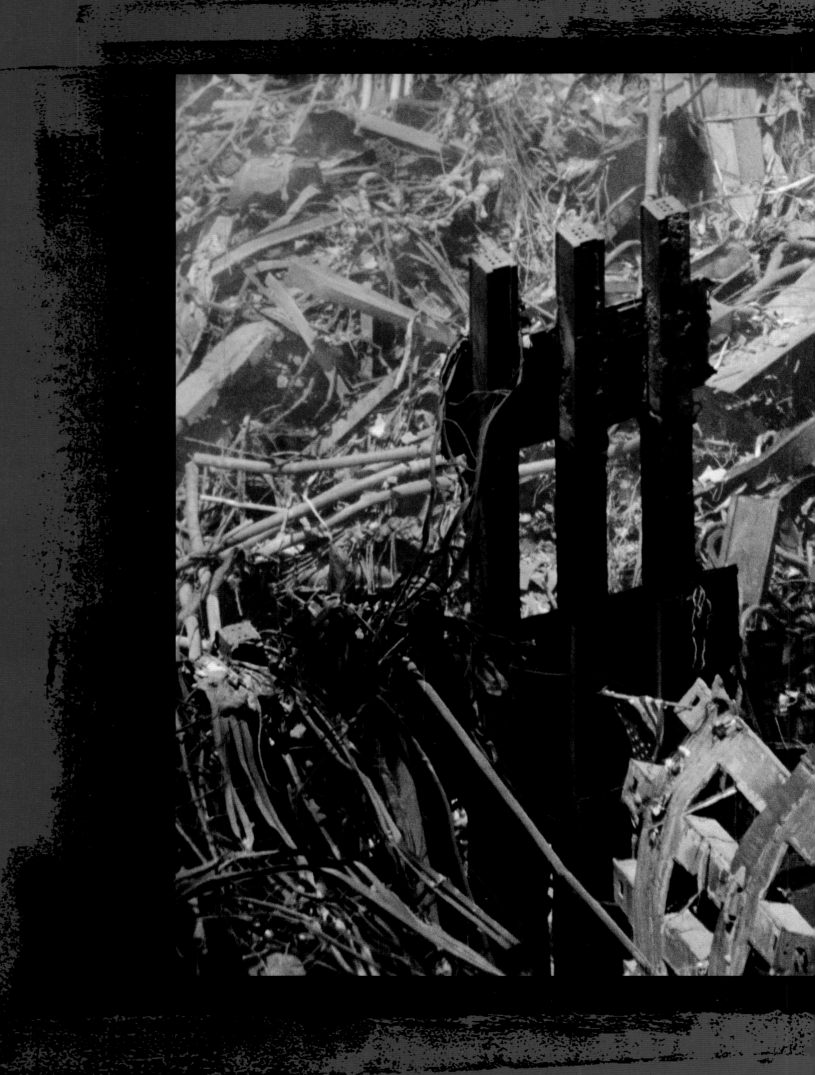

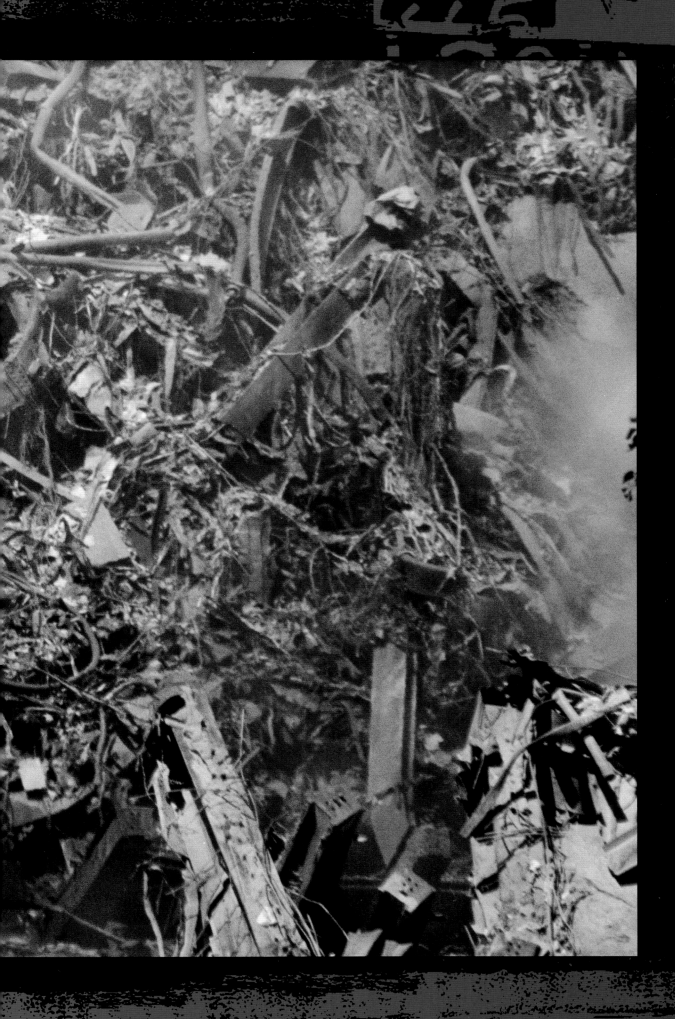

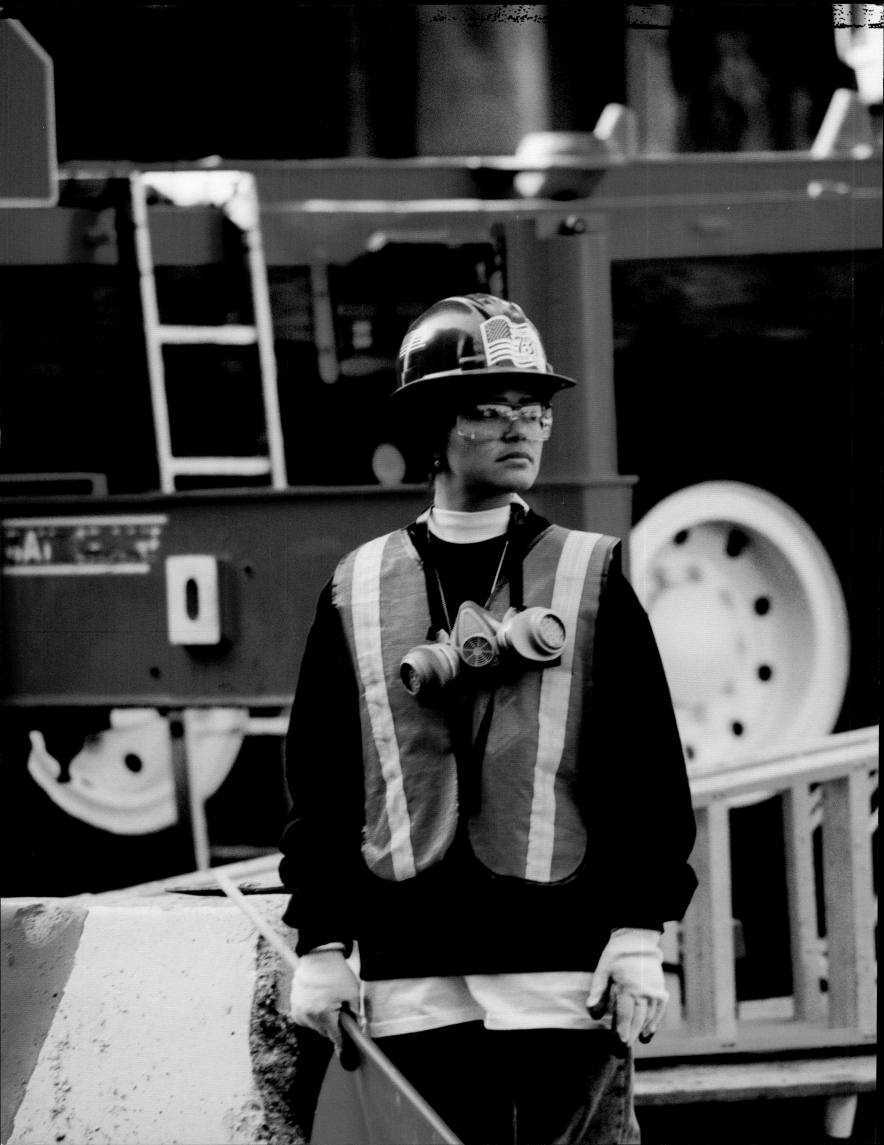

. . . or the people who came to their rescue and died there, the

upon thousands of them, I knew th

MISSING

Guy Barzvi 1.

MISSING:
LAWRENCE "LARRY" BOISSEAU
AGE: 36

WORK AT: OCS SECURITY AS FIRE SAFETY DIRECTOR
LAST SEEN AT 91ST FLOOR AT TOWER ONE.
HIS JOB WAS TO EVACUATE AND ASSIST PEOPLE TO
SAFETY.

HE WAS WEARING GRAY BLAZER WITH PORT
AUTHORITY LOGO,
WHITE SHIRT AND GRAY PANTS.

MISSING

Michael G. Jacobs

LAST SEEN:

MARIETTE BECKLES

COMPANY: Fiduciary Trust Company
BUILDING: Tower #2 95 or 97th floor
Please contact 516-118-0995 or 516-779-6736 or 516-466-1555

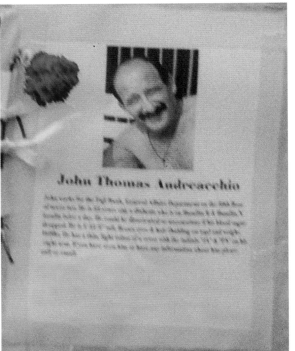

John Thomas Andreacchio

JEFFREY SHAW 42.

TATTOO-SHOULDER
YOSHI KISAN
FATHER OF 2
CANTOR
FITZGERALD
105

MISSING:
Karl Joseph 5'11"
Engine Company 207
Contact Paula Joseph

MISSING
PAUL ORTIZ JR.

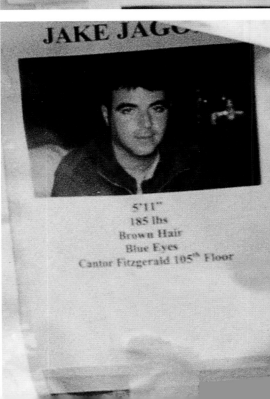

JAKE JAGO...

5'11"
185 lbs
Brown Hair
Blue Eyes
Cantor Fitzgerald 105th Floor

MISSING

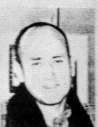

CRAIG NEIL GIBSON

D.O.B. - Dec. ⬤ 1963
Age - 37
Height - 5' 11"
Weight - 170-180 lbs
Eyes - green
Hair - lt brown, receding hairline, No. 1 haircut

Features - small scar on forehead, 1"-2" scar between shoulder blades
Clothing - long sleeve blue Ralph Lauren shirt, dark navy trousers, black belt and shoes, silver TAG watch on left wrist, navy blue + silver stripe backpack
Works for - Guy Carpenter/Marsh McClennan, 94th Floor WTC 1

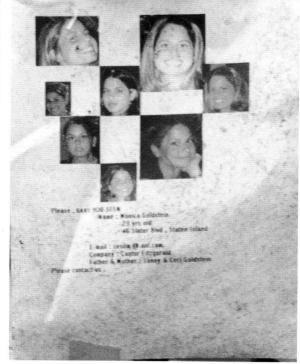

Please, HAVE YOU SEEN
Name : Monica Goldstein
23 yrs old
46 Slater Blvd , Staten Island

E-mail : cesila @ aol.com.
Company : Cantor Fitzgerald
Father & Mother : Sonny & Ceci Goldstein

Please contact us .

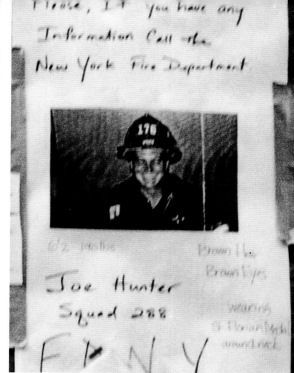

Please, If you have any Information Call the New York Fire Department.

Joe Hunter
Squad 288

Brown Hair
Brown Eyes

wearing a Dinner Napkin around neck.

FDNY

MISSING

HICKNAUTH JAGGERNAUTH
WITH ANY INFORMATION
PLEASE CALL

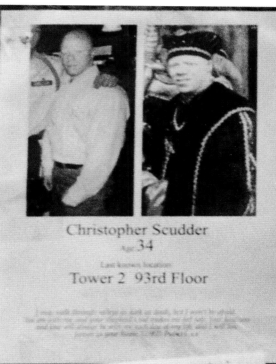

Christopher Scudder
Age 34

Last known location

Tower 2 93rd Floor

Derrick Green 5 feet 5

Contact Melrose Green

SING

MISSING RICHARD Y.C. LEE

IF YOU HAVE ANY INFORMATION ABOUT RICH
PLEASE CONTACT HERBY

DOUG JASON IRGANG

AGE: 32 years old
WEIGHT : 140 lbs
HEIGHT : 5' 8"
EYES : hazel
Identifying scar on right side of his stomach. (large scar)

LAST SEEN @ 2 WORLD TRADE CENTER
WORKS @ Sandler O'Nell Fl 104
IF YOU HAVE ANY INFORMATION
Please contact us

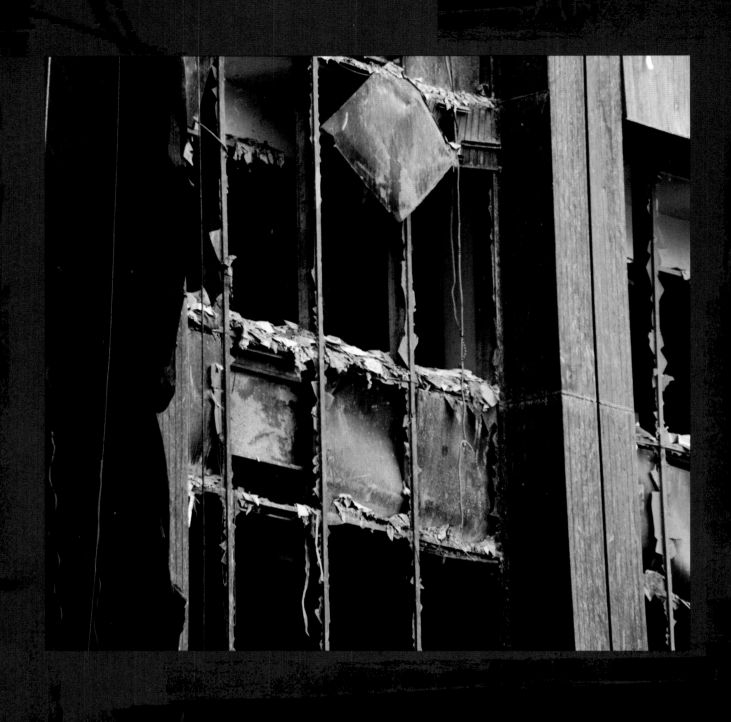

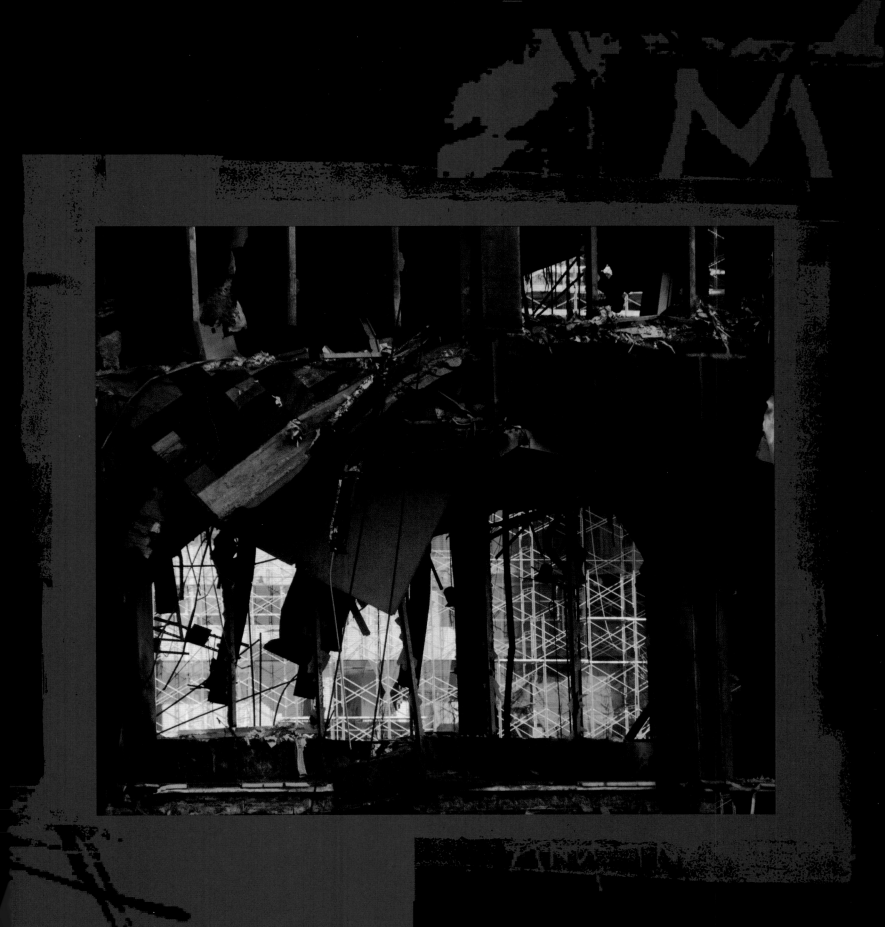

But I counted on them. They were of my city.

edical
uilding

Missing from World Trade Center Building 1
106th Floor Windows on the World

John F. Puckett

John F. Puckett
24 Titus Road
Glen Cove, NY

Age: 47 dob: 2/2
Height: 6'3" 175 lbs
General Description: Tall, slender, glasses
Thinning light brown hair, distorted thumb on left hand
Tumor behind right ear. Size 13 shoes
John is assumed to last be seen setting up the
audio for a conference/meeting at
Windows on the World on the 106th floor of Building 1 WTC.
John was wearing a black suit, white shirt & tie.

5'10", 180lbs.
Blue Eyes
Lt. Brown Hair

M
I
S
S
I
N
G

SWEDE CHEVALIER
WTC#1, 104th Floor
CANTOR FITZGERALD

MISSING

John
Chipura

11/27/61
5'10"
265 lbs.

LADDER COMPANY
FDNY 105

Multiple Native American tattoos

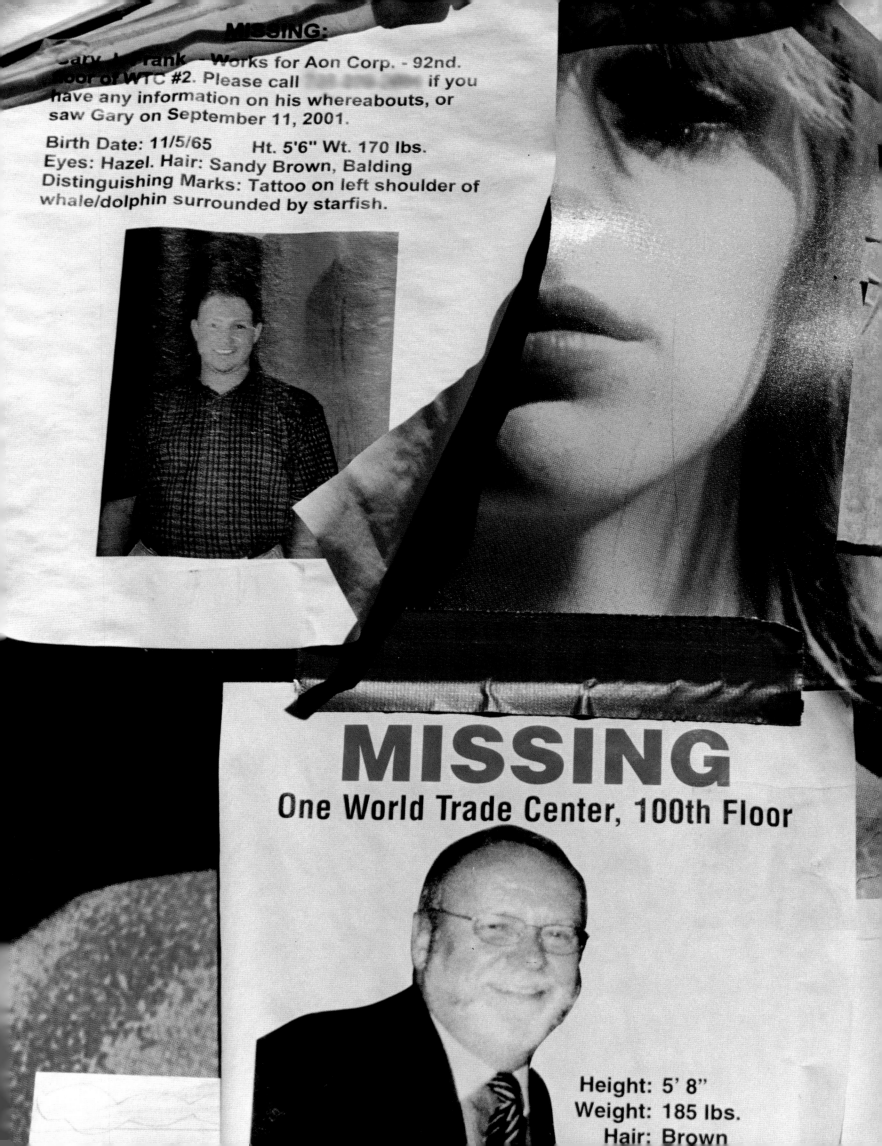

MISSING:

Gary J. Frank – Works for Aon Corp. – 92nd. floor of WTC #2. Please call ▮▮▮▮▮▮▮▮ if you have any information on his whereabouts, or saw Gary on September 11, 2001.

Birth Date: 11/5/65 Ht. 5'6" Wt. 170 lbs.
Eyes: Hazel. Hair: Sandy Brown, Balding
Distinguishing Marks: Tattoo on left shoulder of whale/dolphin surrounded by starfish.

MISSING
One World Trade Center, 100th Floor

Height: 5' 8"
Weight: 185 lbs.
Hair: Brown

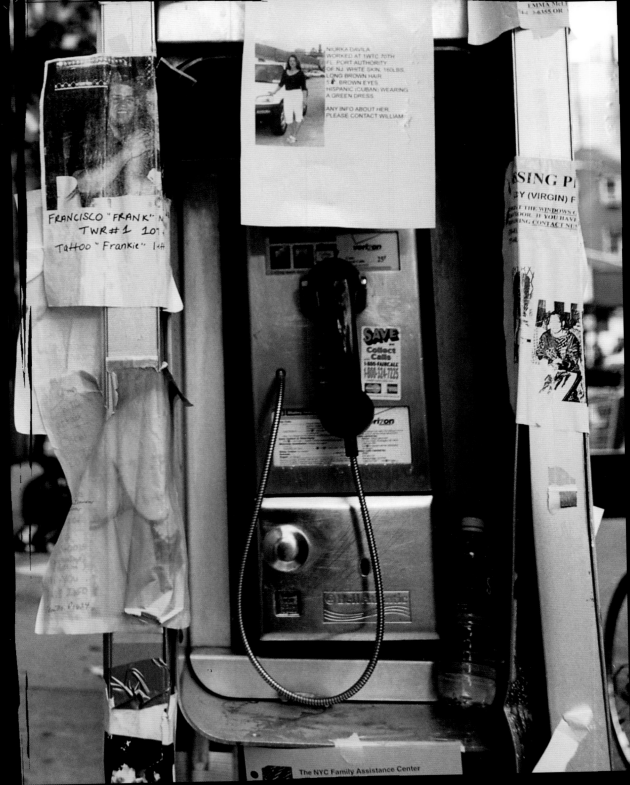

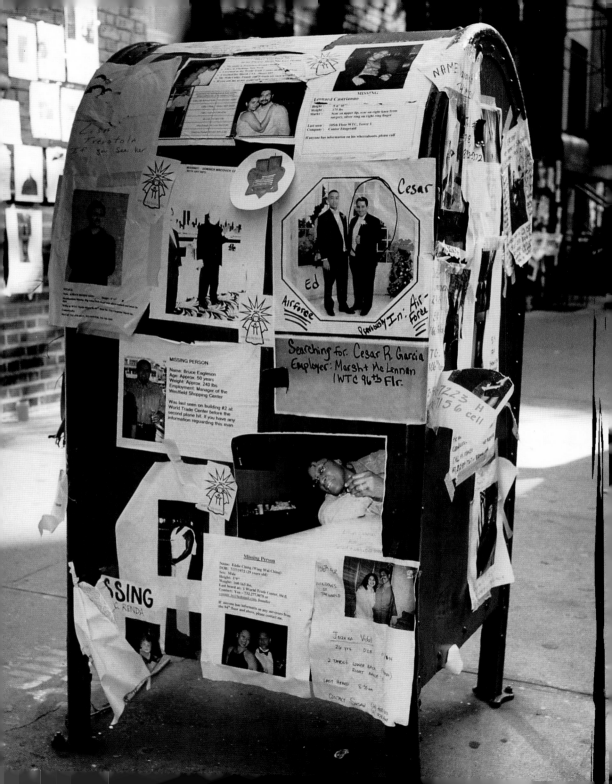

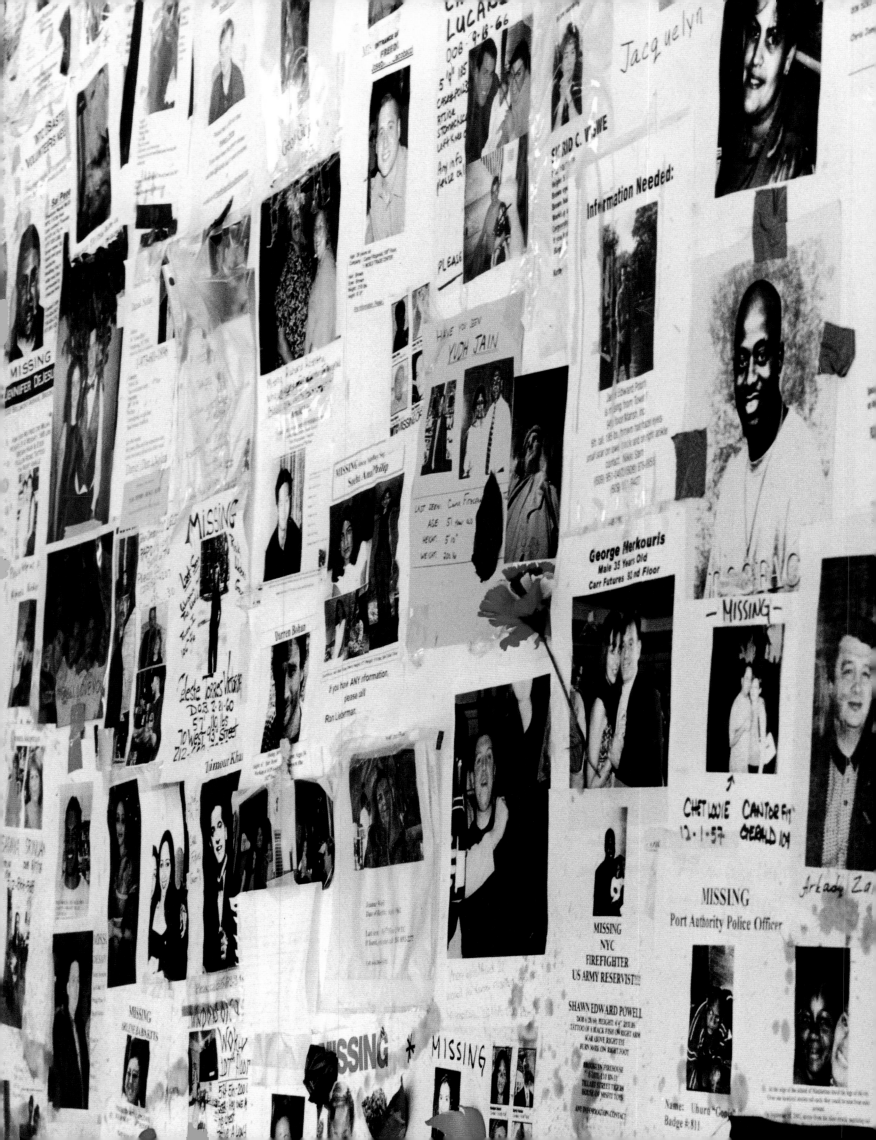

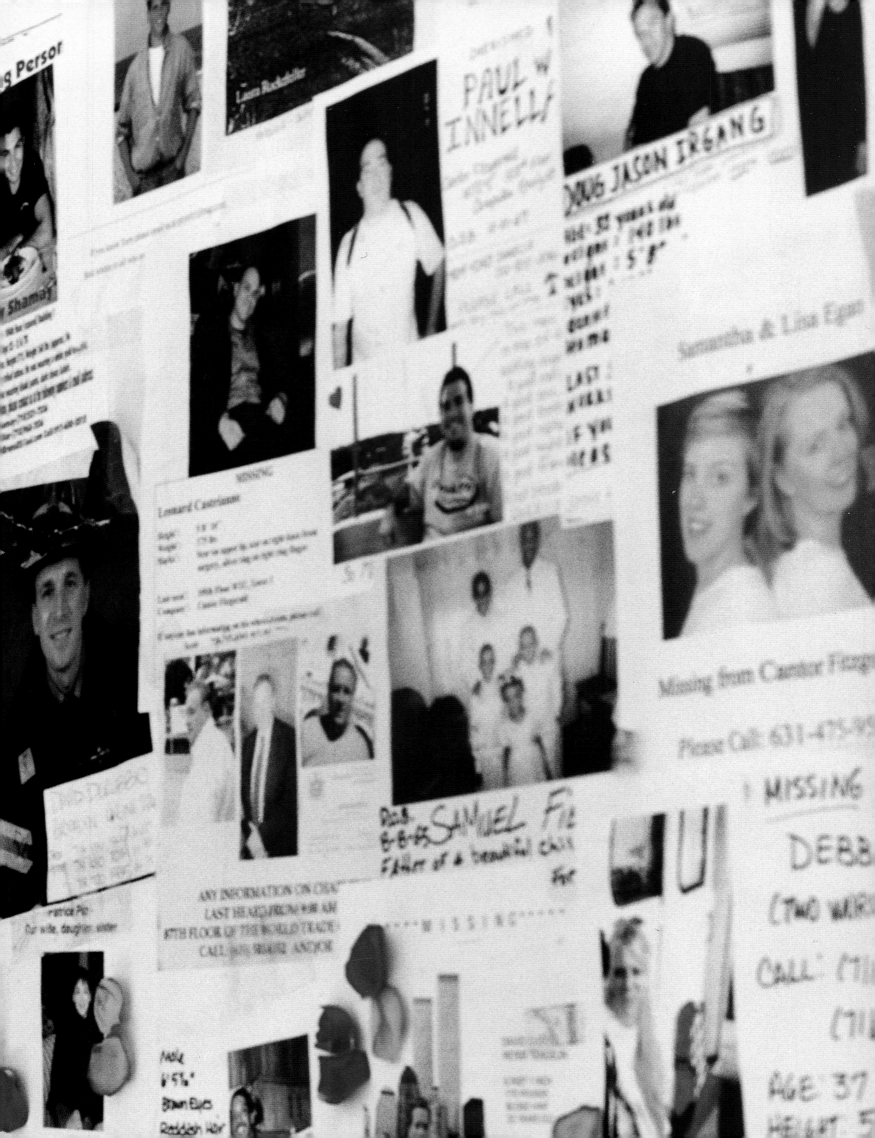

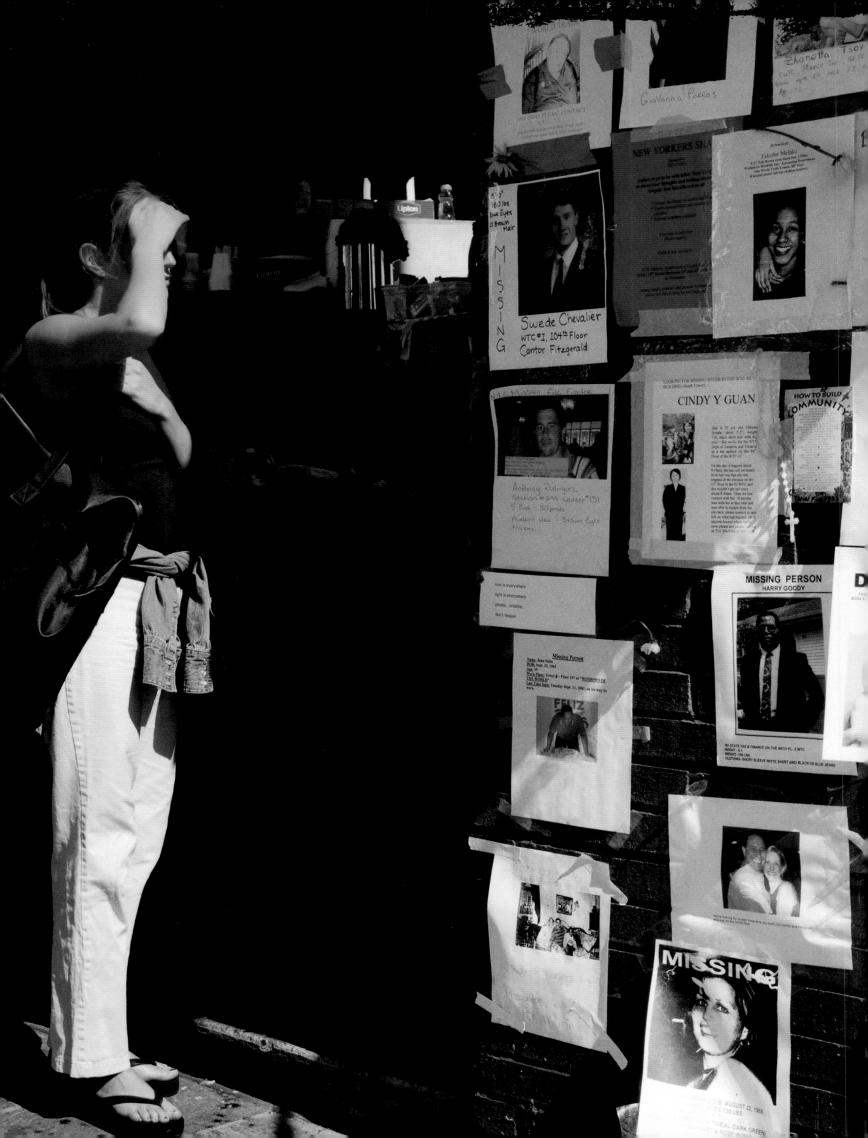

We were to have moved through life together

in all our generations . . .

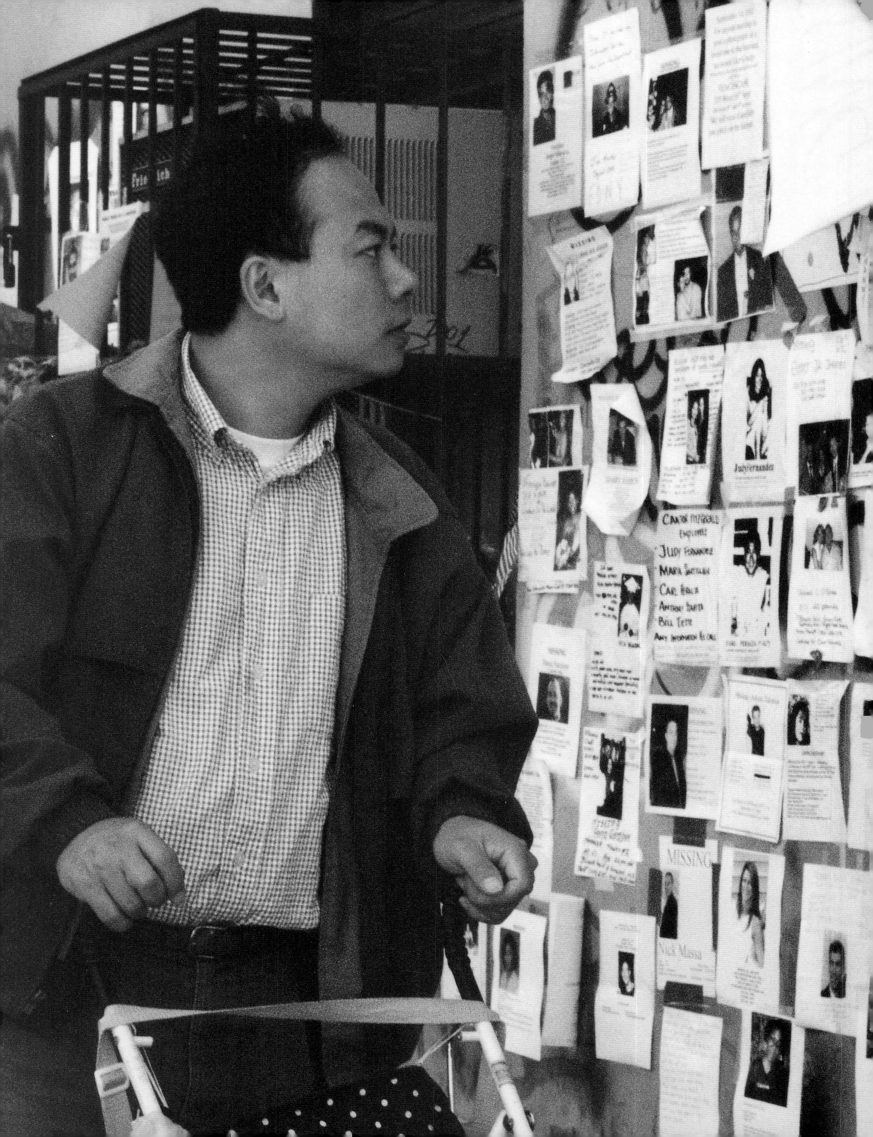

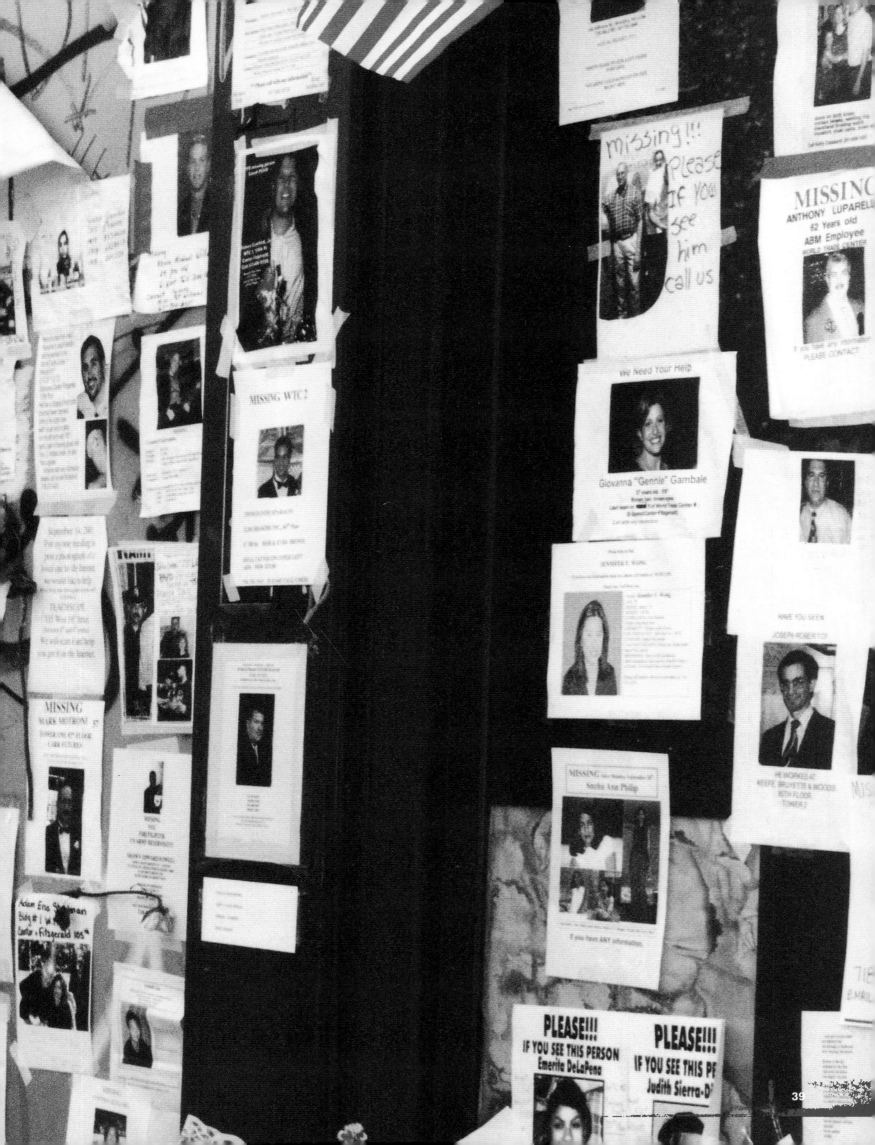

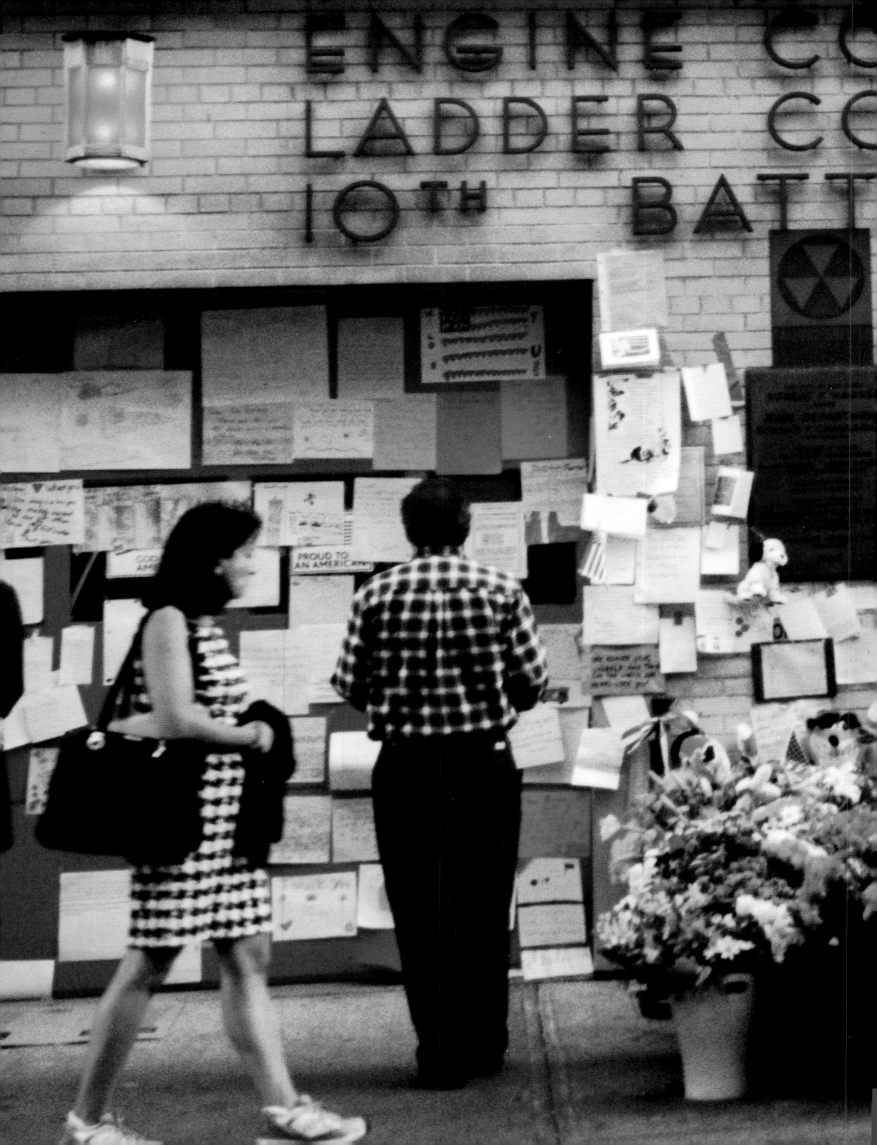

We naturally understood one another though we had never met . . .

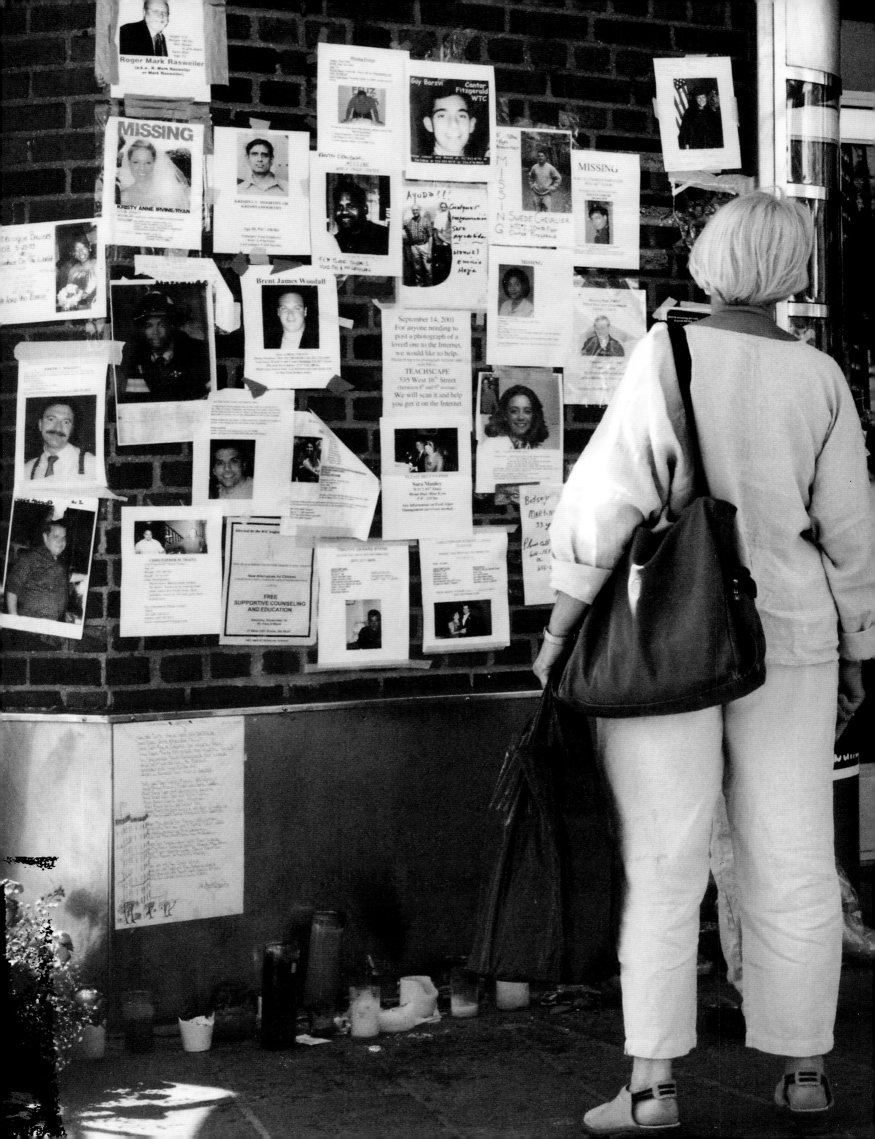

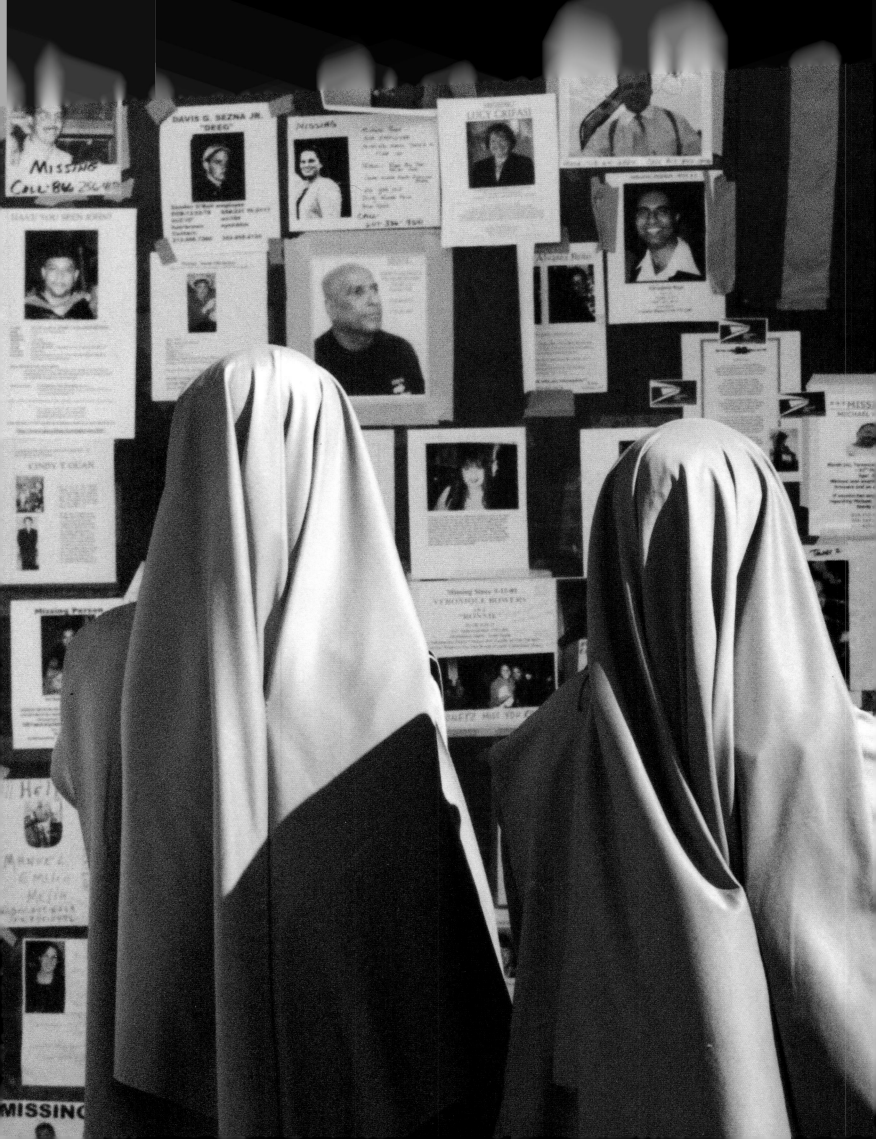

I would have been comfortable having coffee or a drink with any one of them.

HAVE YOU SEEN
MY DADDY?
JASON JACOBS

PLEASE CALL

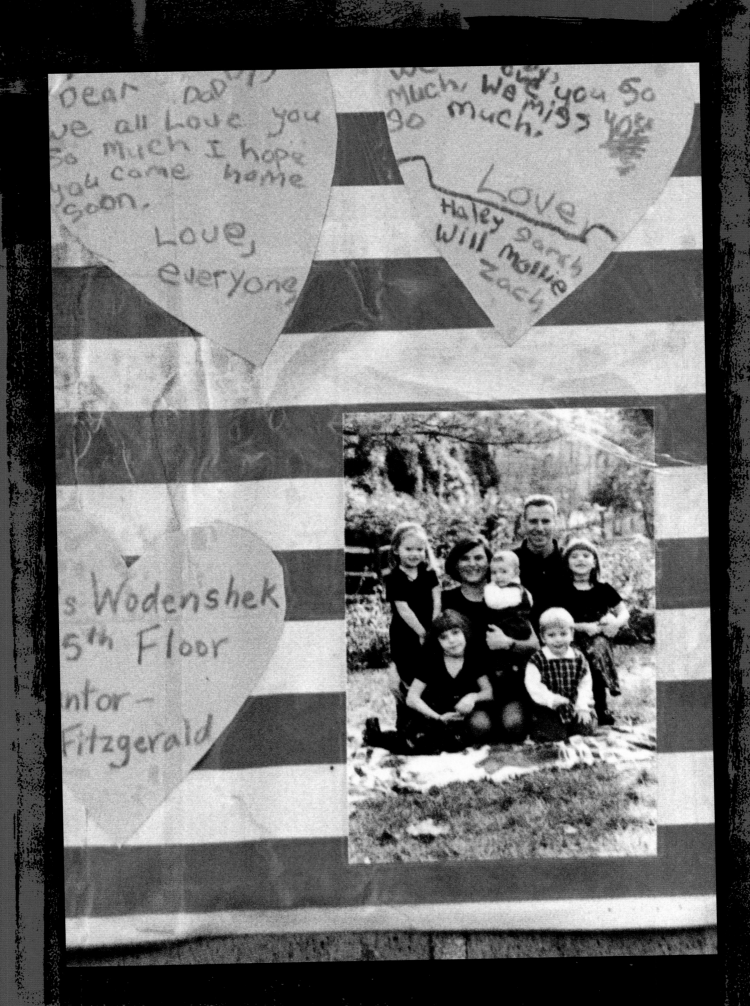

49

The rhythms of their speech were my rhythms,
the figures of speech, the attitudes, the postures, the moods,
were my rhythms and phrases, my attitudes and postures and mood
It would have been in our natures, under the right circumstances,
to call one another by our first names and to speak of where we
grew up and what we did for a living . . .

MISSING!!!

Joseph A. Eacobacci

Age: 26 years old
Company: Cantor Fitzgerald, 105th Floor,
 1 WORLD TRADE CENTER
Hair: Brown
Eyes: Brown
Weight: 210 lbs.
Height: 6' 0"

LOCAL #608

PATRICK WOODS

36 YRS. old

FEATURES: 6' 1"/ 200 LBS / SANDY BLOND HAIR / BLUE
EYES... DENTAL WORK DONE ON FRONT TEETH...HAS A 2
INCH SCARE ON EACH RIB CAGE FROM SURGERY

TAIMOUR KHAN

29 YRS. OLD
5 "10' - 150 PDS.
DK. BROWN HAIR-L.. INE

..ORLD TRADE - 92ND FL.
..RR FUTURES

..ELP FIN..

We would have made our private judgments of one another,
we might have pointed out our differences in age, in education,
in background, but we were of the same cloth,
we were one another's context, . . .

. . . in our numbers we provided

the urgent life of the city for each one of us.

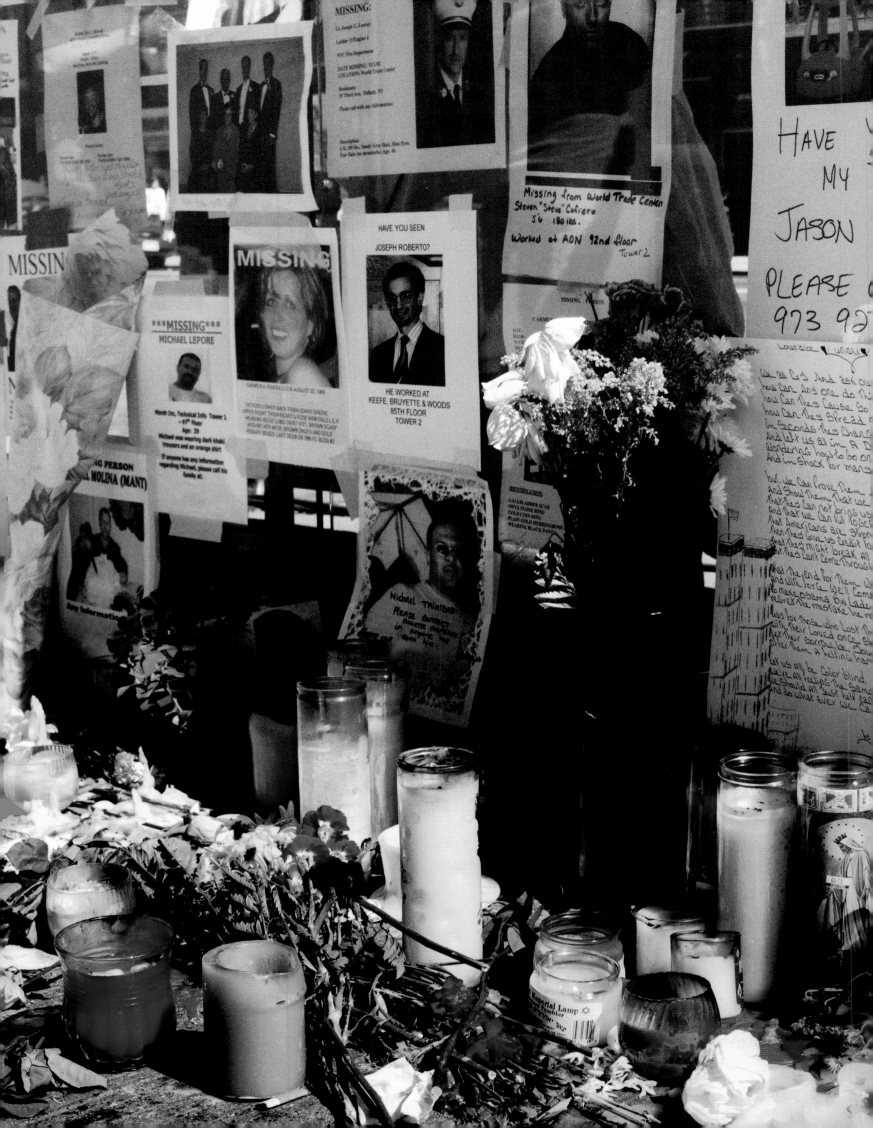

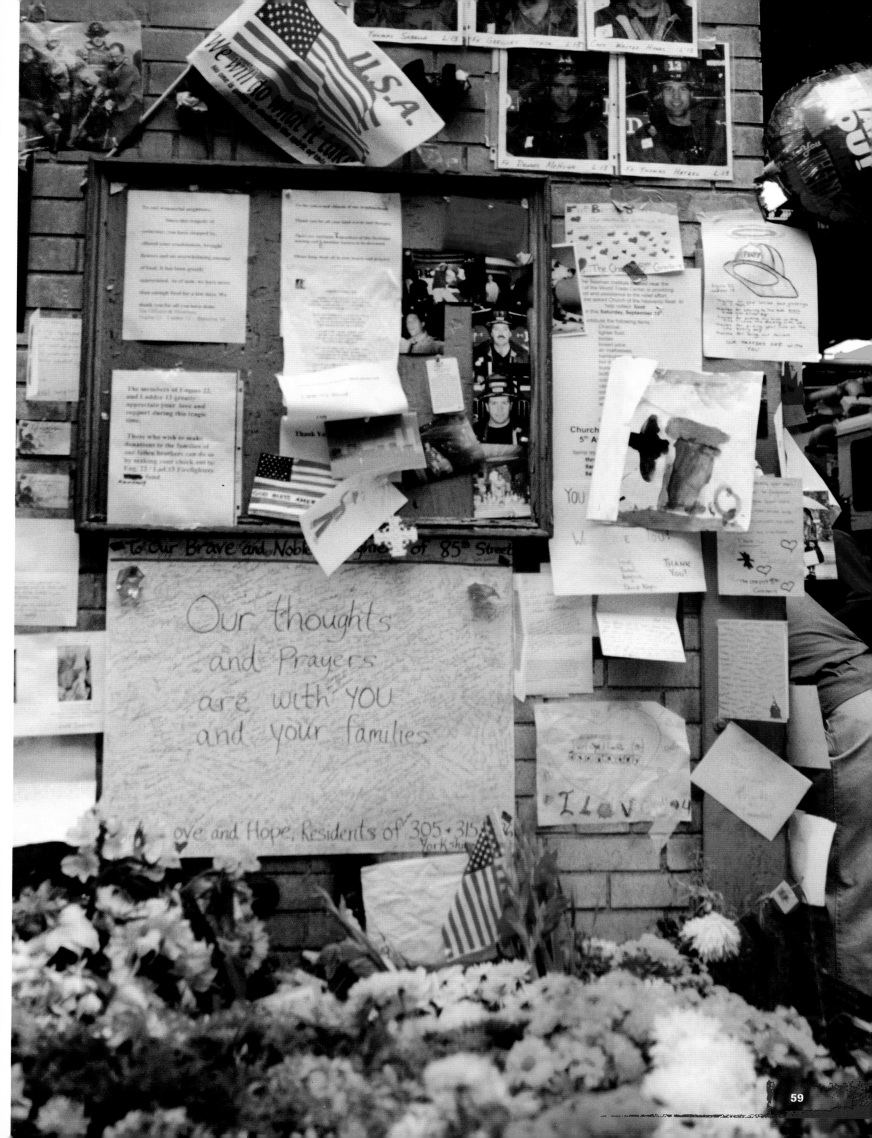

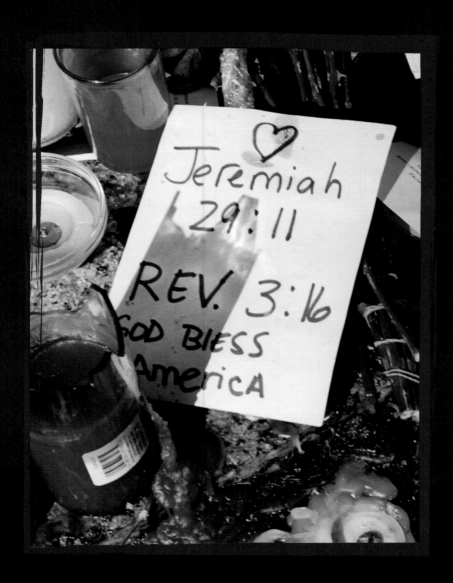

As strangers, we had an understanding.

We would appear on the perimeters of one another's consciousness,
in one another's sightlines, on any given day, passing in the street, riding
the subway, shopping for our families, going to the ballgame, waiting on
the same street corners for the light to change, heading home to the joy of
our children, taking the same holidays, affirming our lineage by the births,
graduations, weddings and funerals of our families, all of us doing the
same things in our different ways, mirroring one another's daily lives as
we flowed through the streets or rode under them, always intent on our
business within the dimensions of our city.

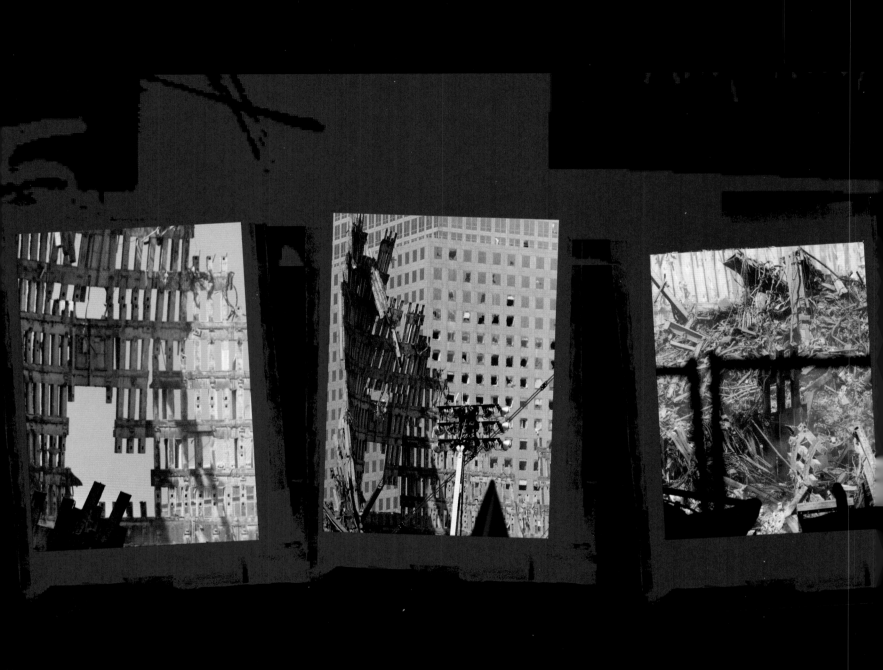

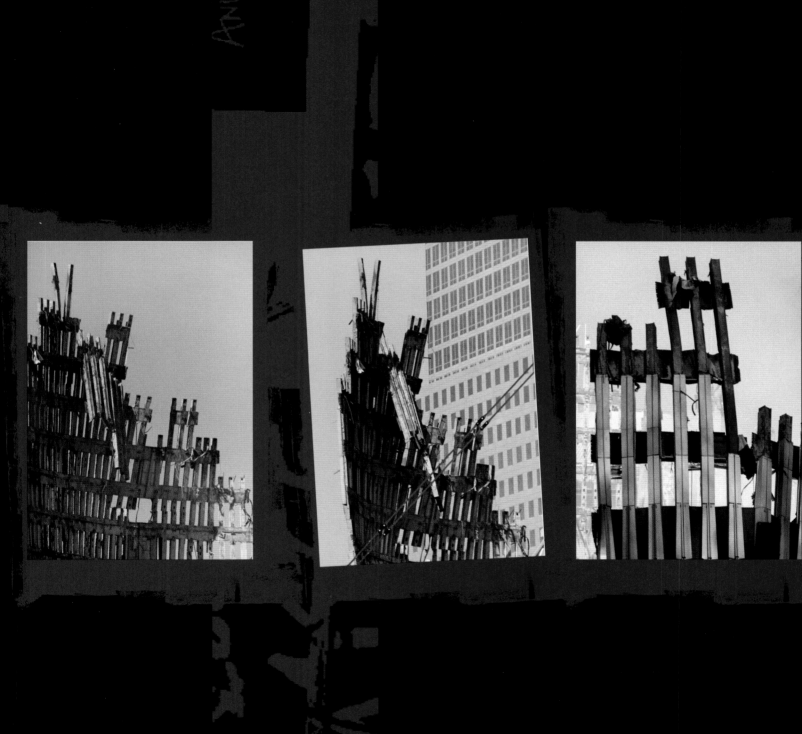

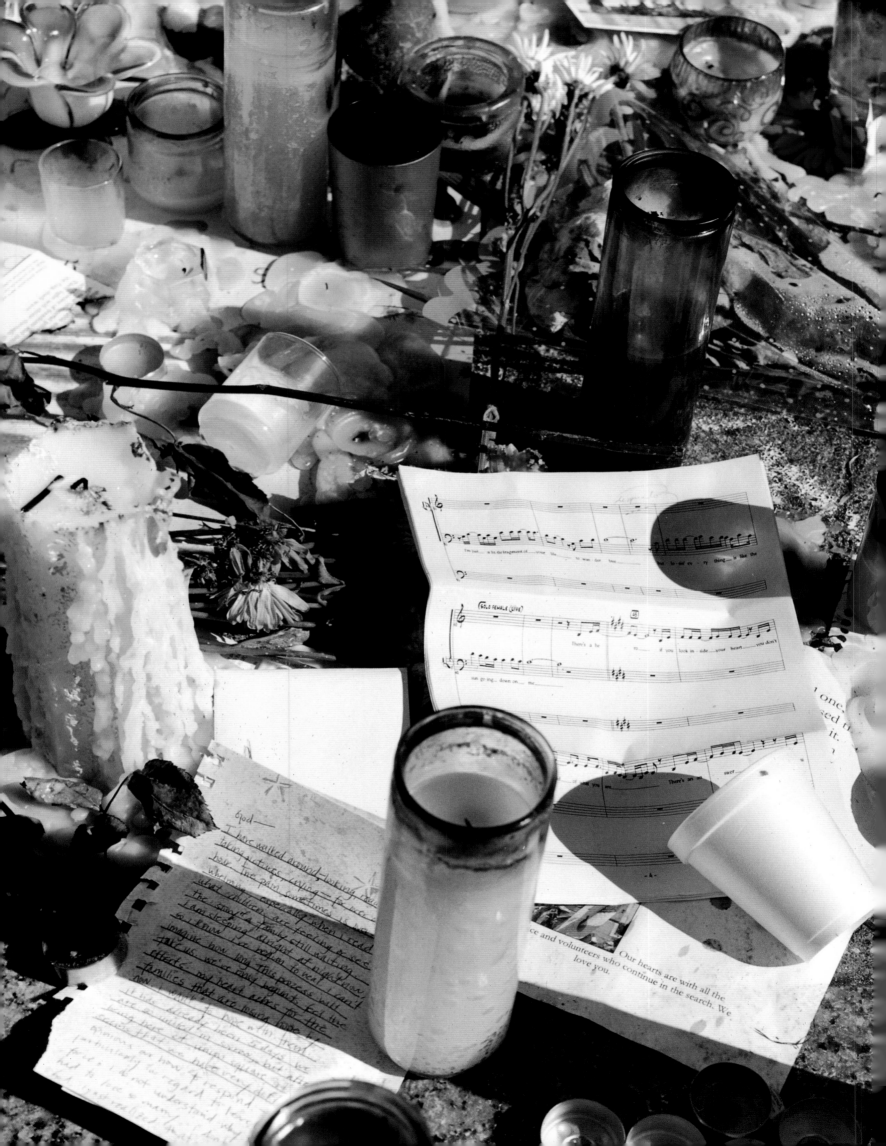

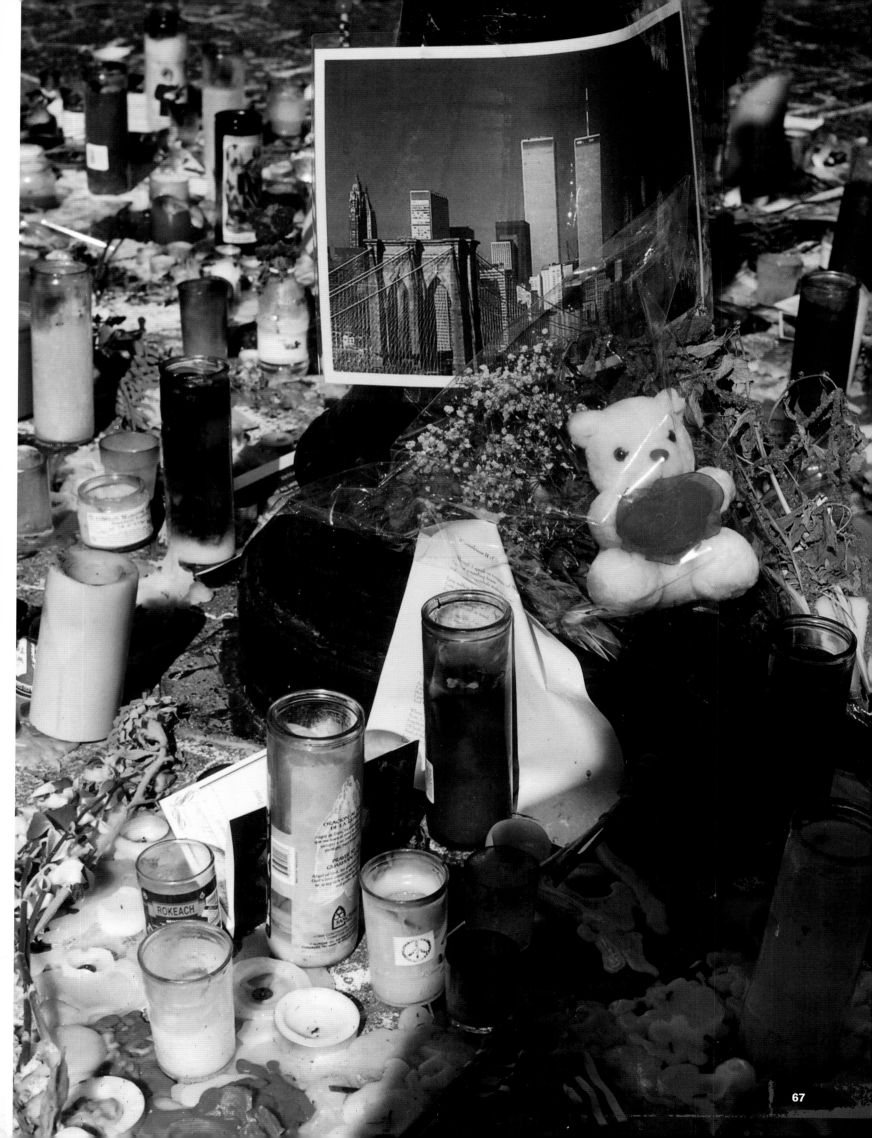

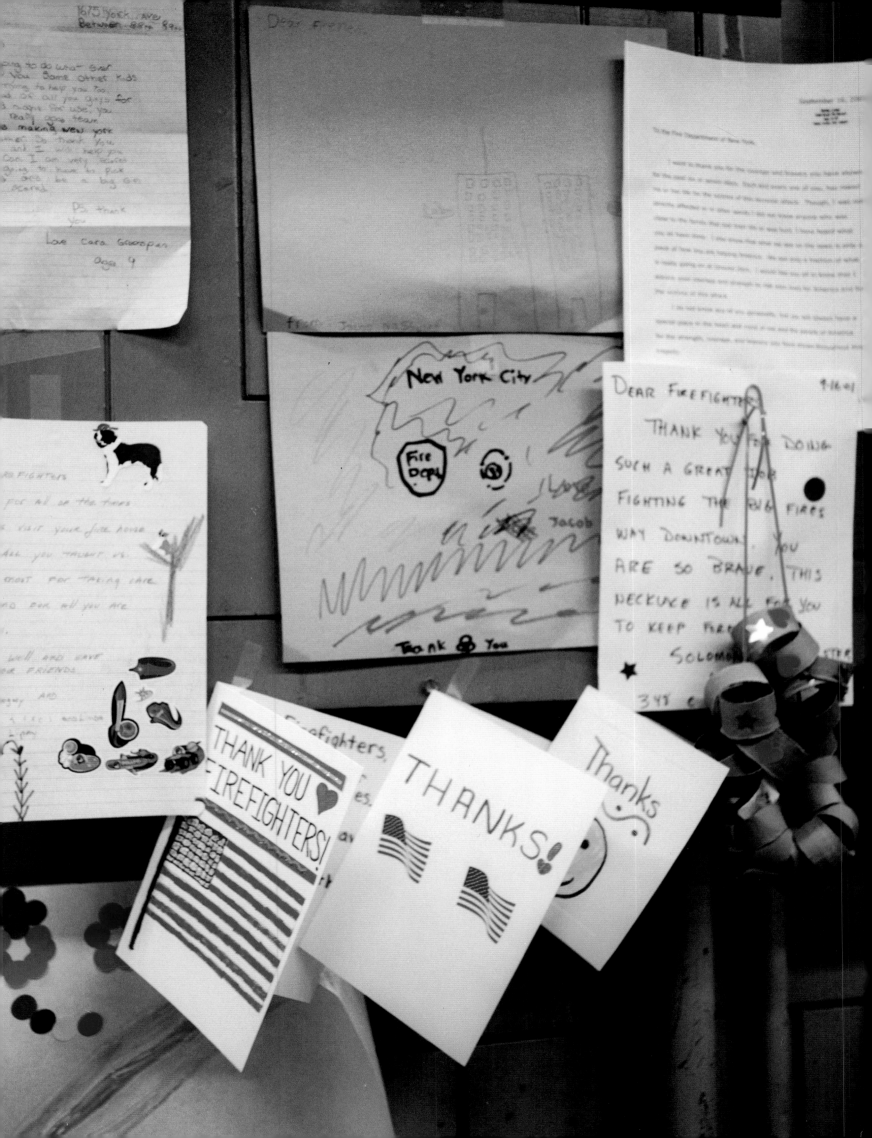

We were joined too by the belief that underneath all our flaws
and weaknesses and angers and stupidities, was a bedrock human
decency, and that despite any lack of consideration we may
have shown one another there was always the possibility, through
our acts of atonement, self-recognition and mercy, of reforming,
of finding redemption on any given day to the day of our death.

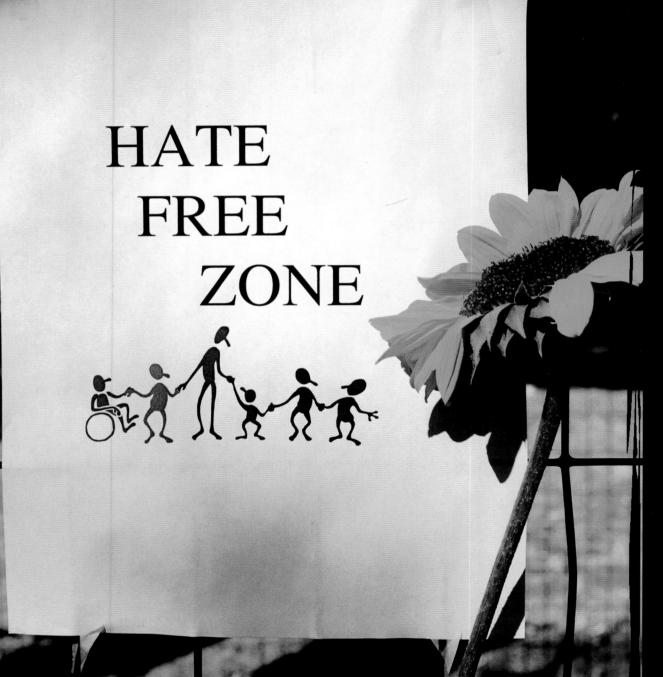

In our unspoken fervent love of the freedom that grants to each of us the ultimate command of our own lives, we knew we were privileged not by our material wealth but by the choice that was ours to live life any one of a thousand ways, to ennoble ourselves or degrade ourselves, to believe or disbelieve — whatever our struggles, and through what convolutions of thought, everything we made of ourselves being up to us, a matter of our private determination under a system of governance that, however imperfect, could not intervene in the life of our souls.

THANK

F. D. N. Y

&

NYPD Blu

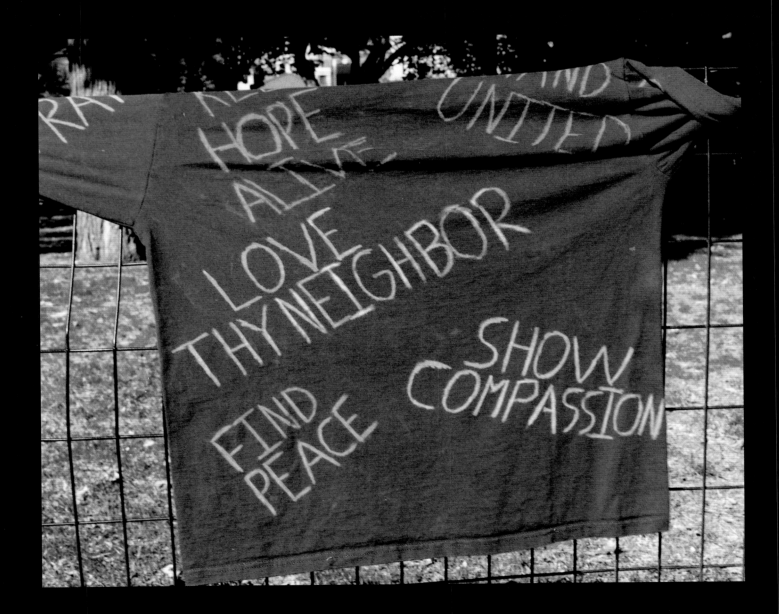

We understood that we may only grudgingly accept our differences
but in this city there are no infidels, no philistines and no eternally damned . . .

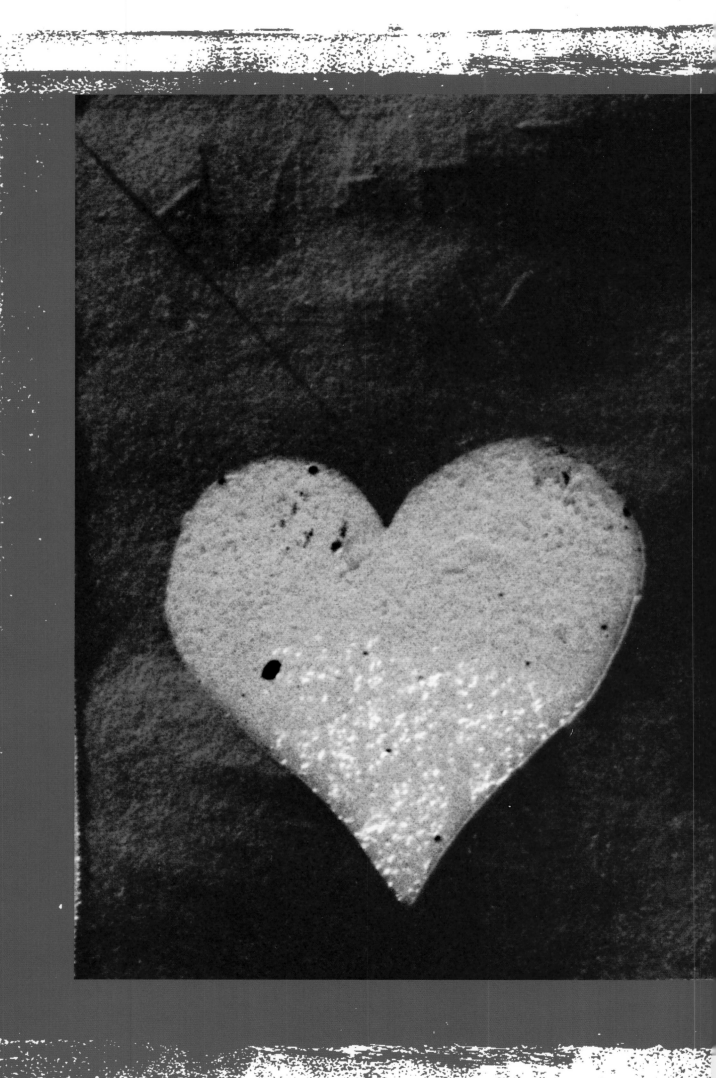

. . . and that none of us is that presumptive to claim so,
however ardent we are in our observance of what we believe.

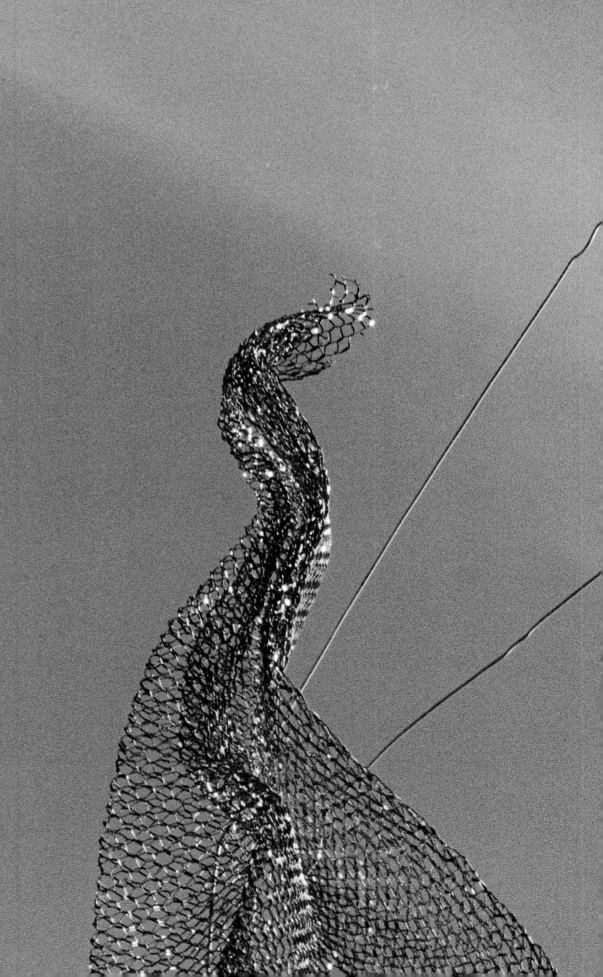

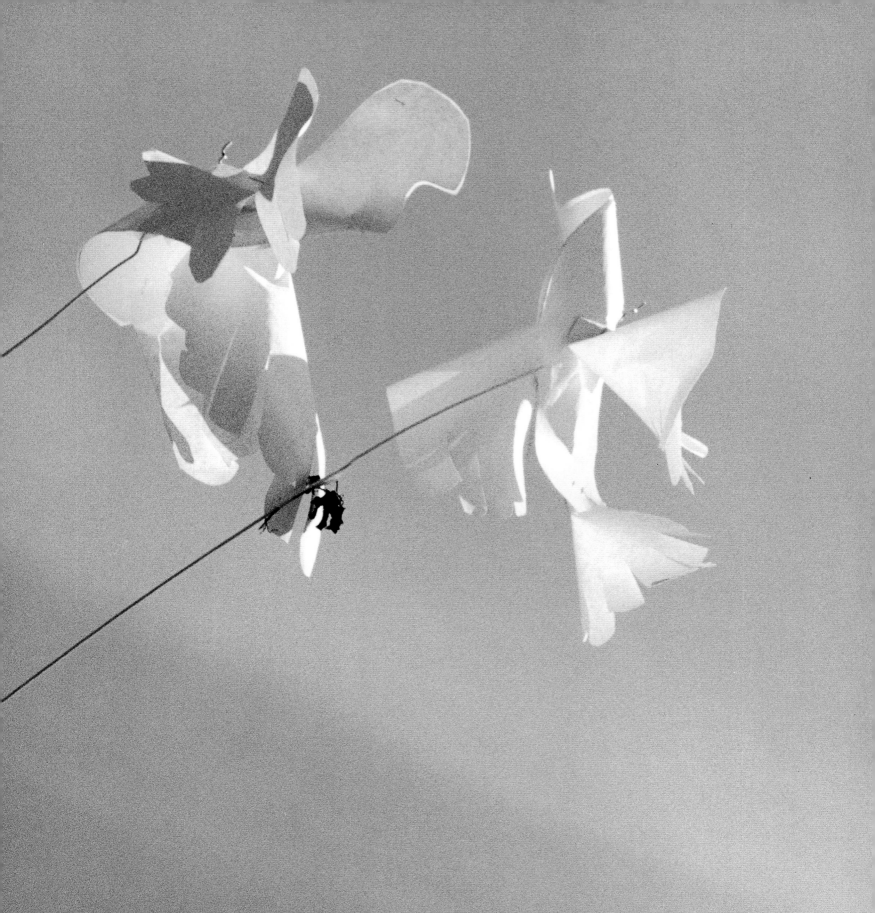

Some of us may even have recognized the possibility of God's blessing in the struggles of those who can't quite accept Him. But for all of us our relationship to God is finally a private matter, our own business, no one else's. And that is the way we lived, and will live, in the necessary humility of the secular state.

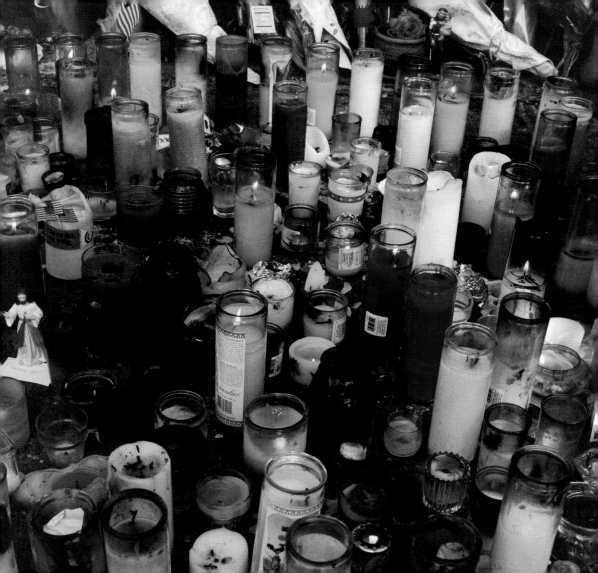

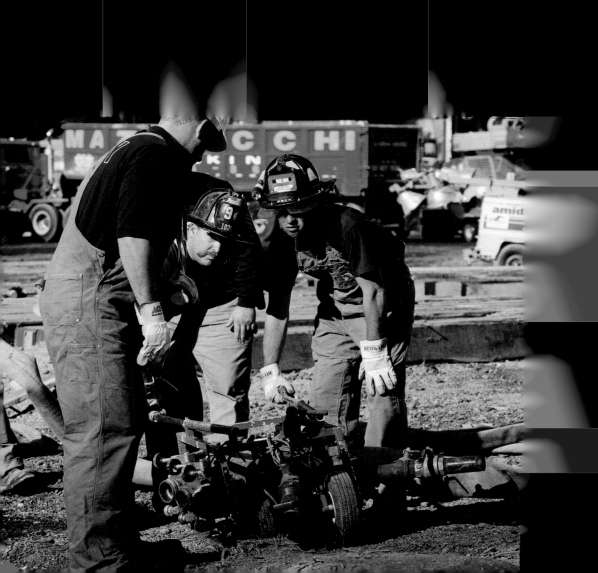

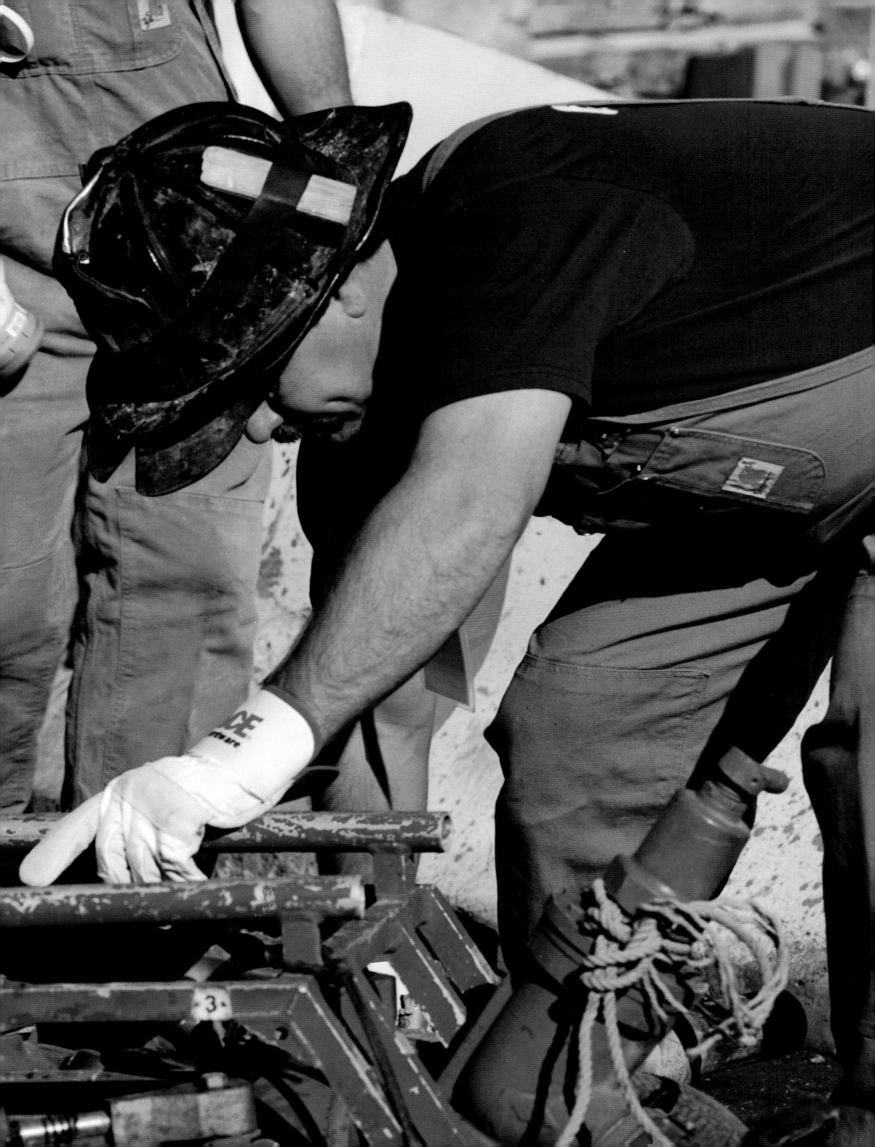

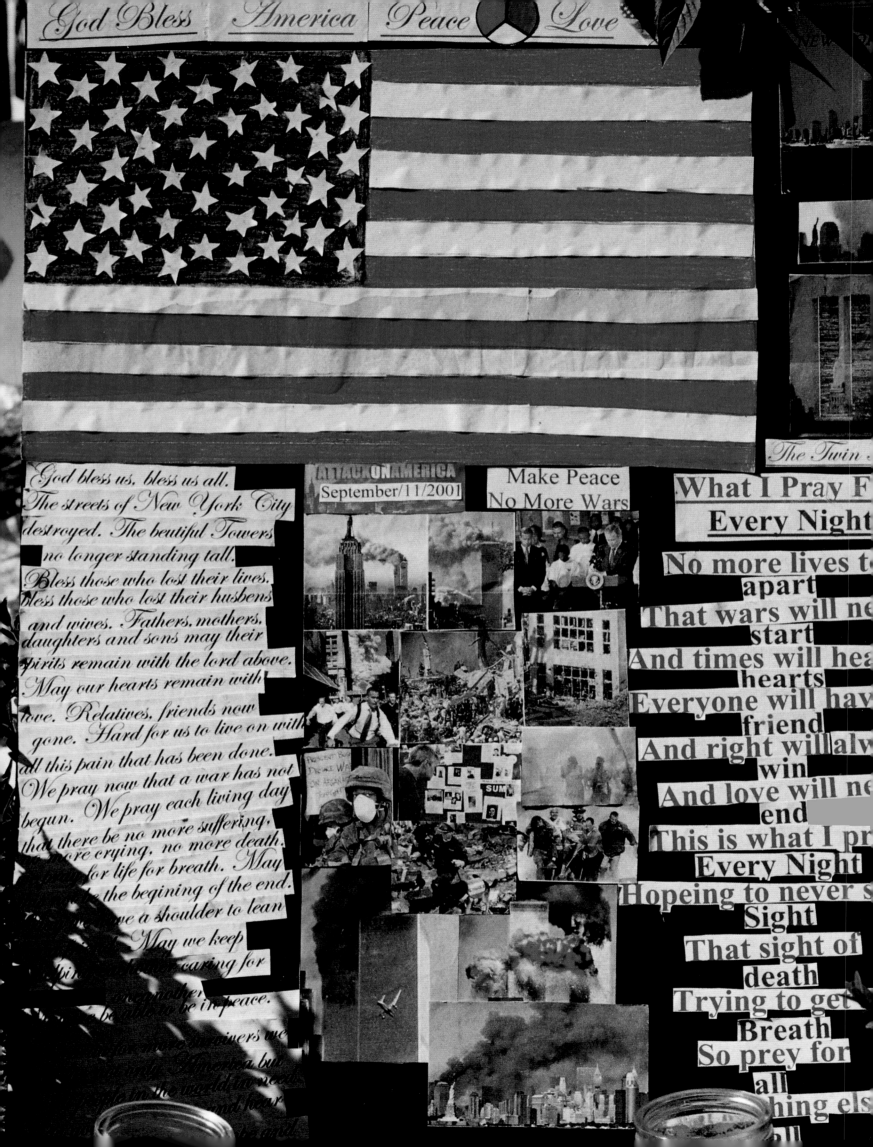

God Bless | America | Peace ⊕ Love

God bless us, bless us all.
The streets of New York City
destroyed. The beutiful Towers
no longer standing tall.
Bless those who lost their lives,
bless those who lost their husbens
and wives. Fathers, mothers,
daughters and sons may their
spirits remain with the lord above.
May our hearts remain with
love. Relatives, friends now
gone. Hard for us to live on with
all this pain that has been done.
We pray now that a war has not
begun. We pray each living day
that there be no more suffering,
no more crying, no more death.
for life for breath. May
the begining of the end.
a shoulder to lean
May we keep
caring for
be in peace.

ATTACK ON AMERICA
September/11/2001

Make Peace
No More Wars

The Twin

What I Pray F
Every Night

No more lives t
apart
That wars will ne
start
And times will hea
hearts
Everyone will hav
friend
And right will alw
win
And love will ne
end
This is what I pr
Every Night
Hopeing to never s
Sight
That sight of
death
Trying to get
Breath
So prey for
all
hing e

This country and its institutions are a work in progress . . .

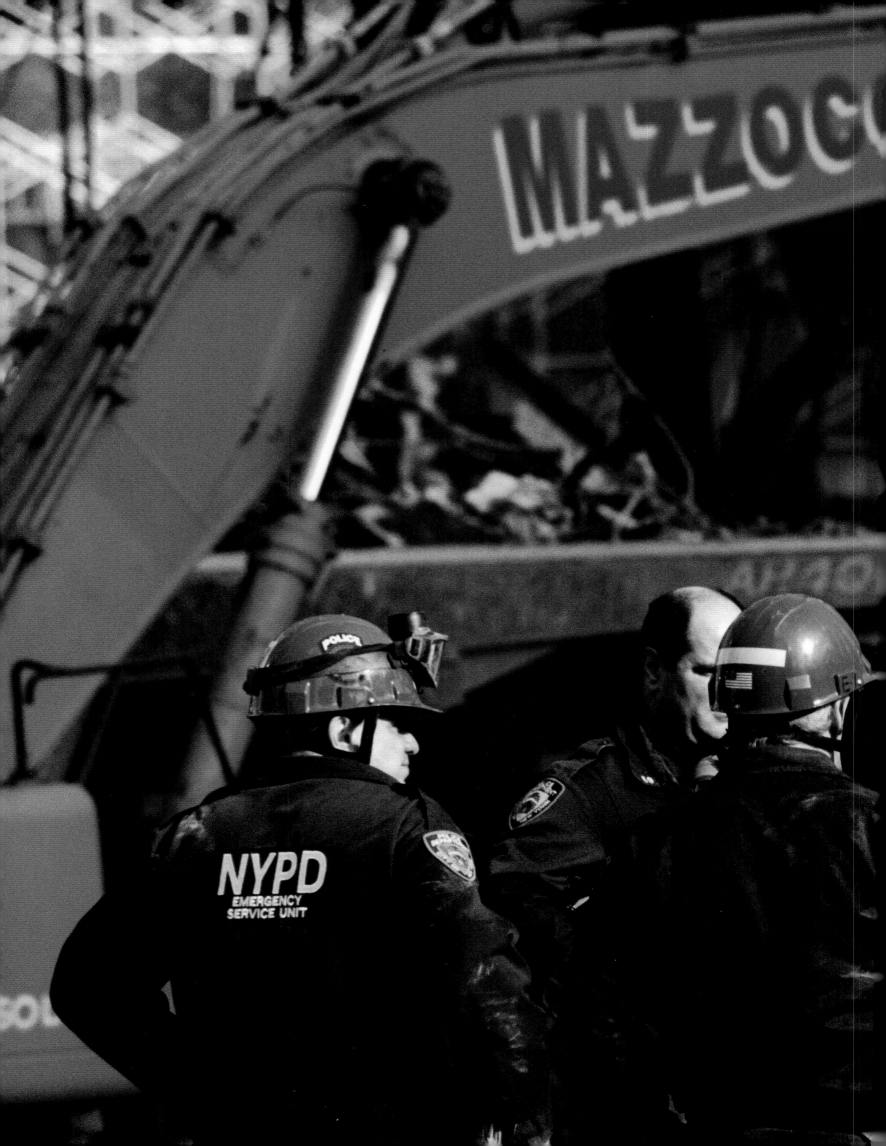

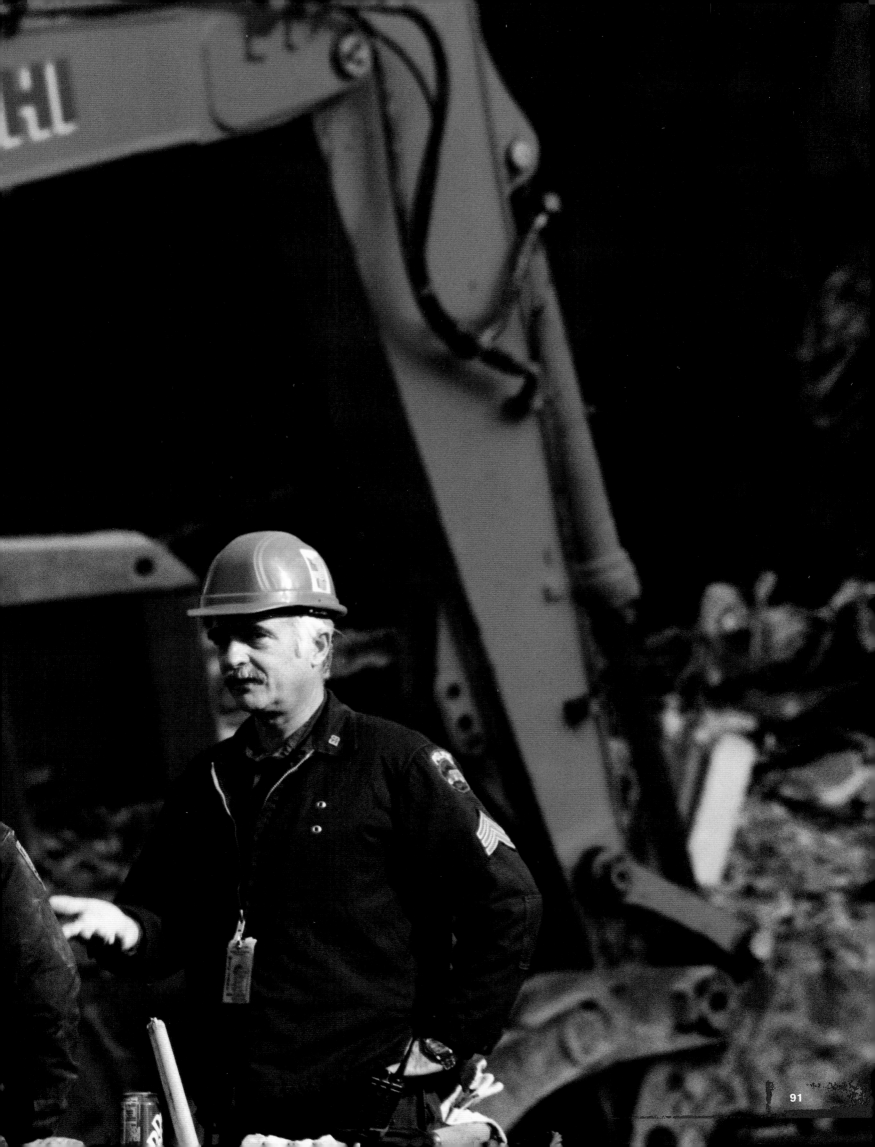

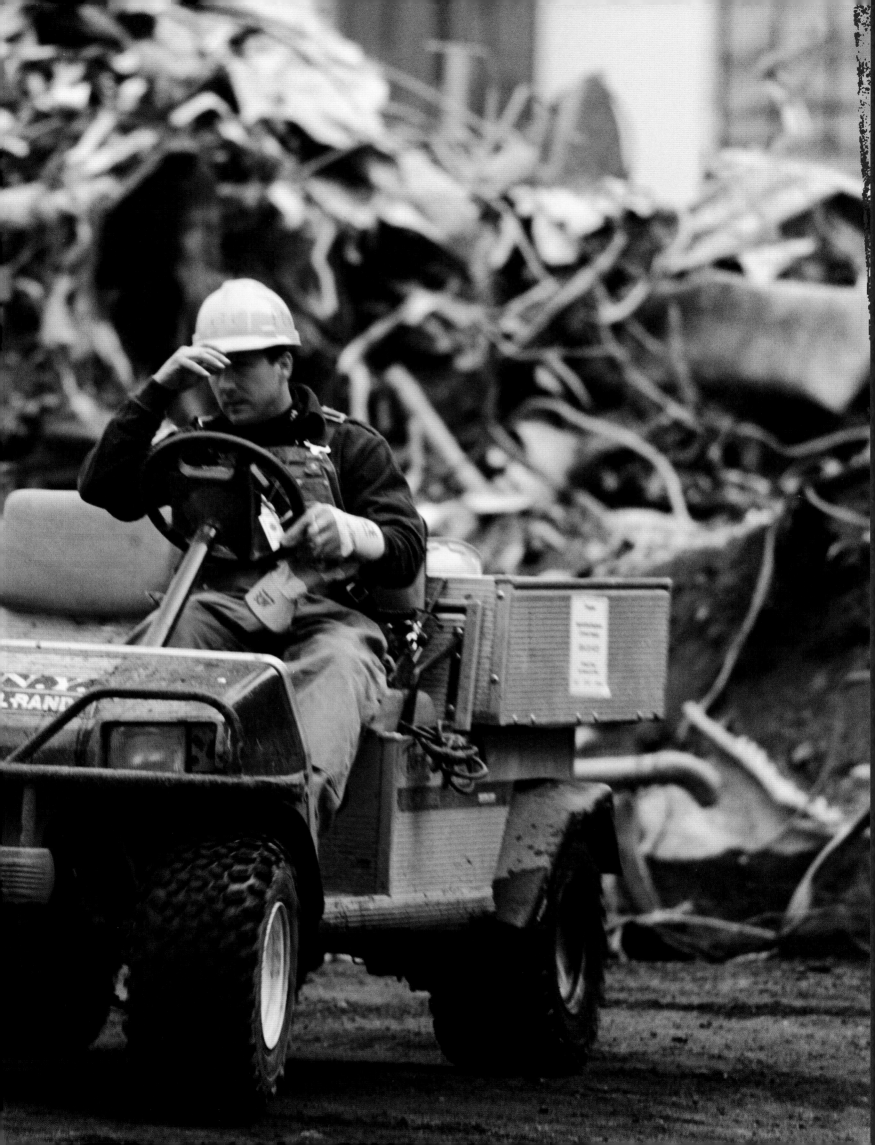

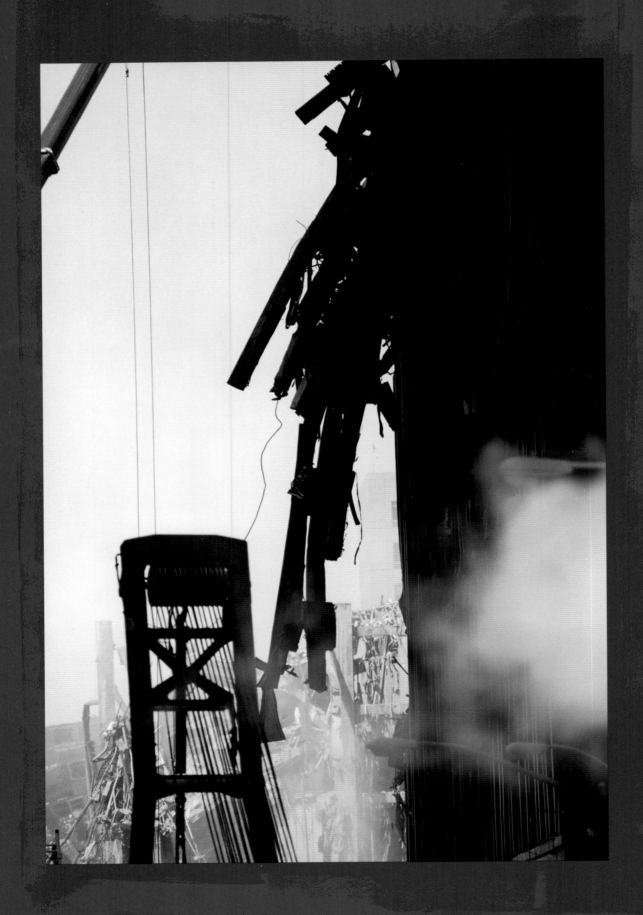

Our story has just begun . . .

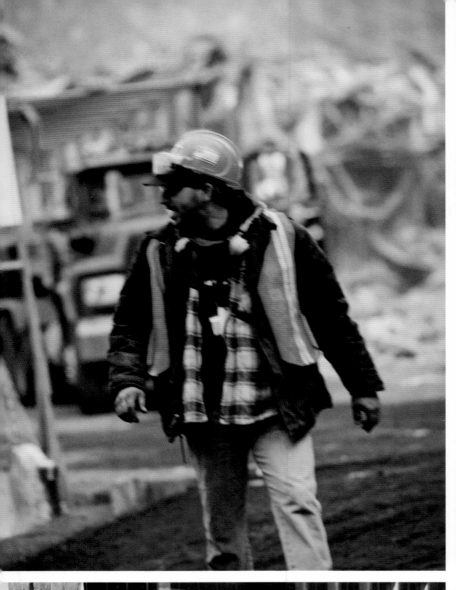
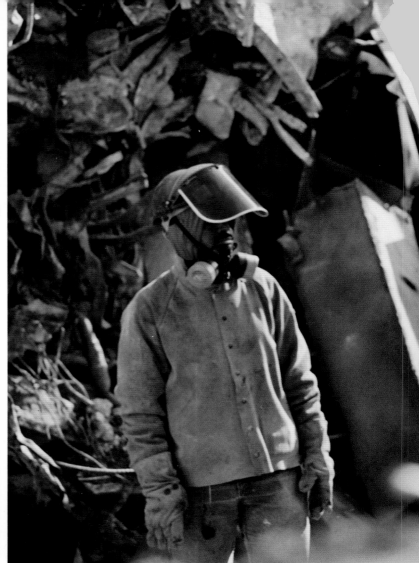
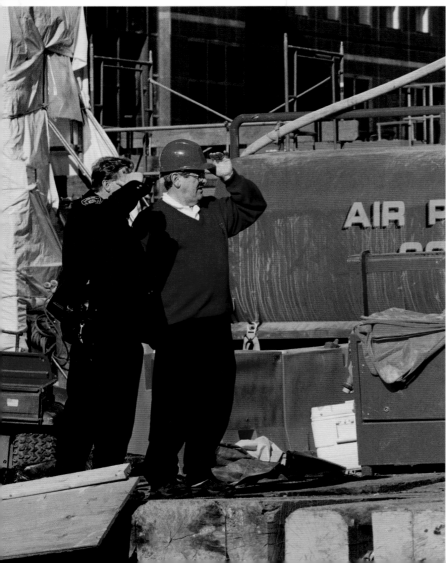
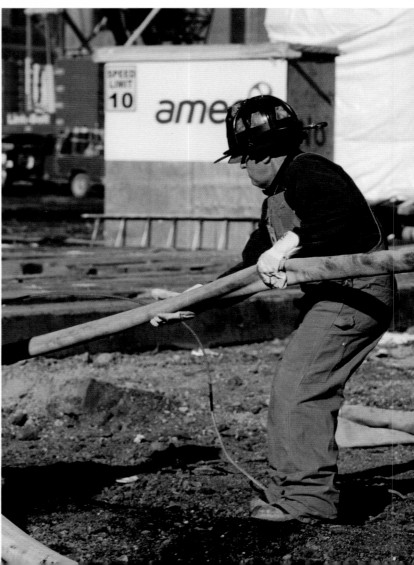

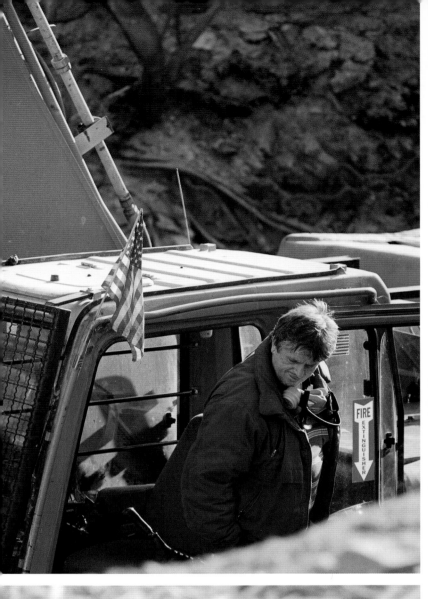

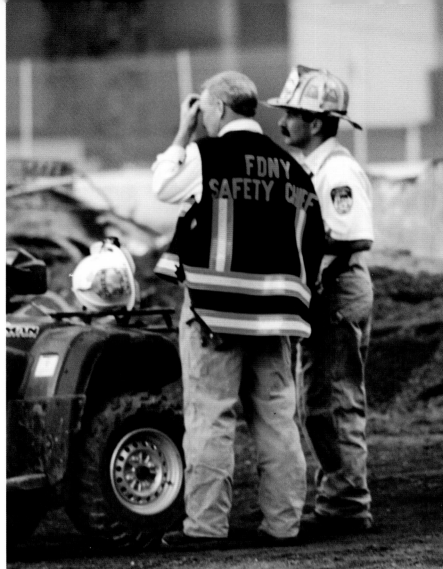

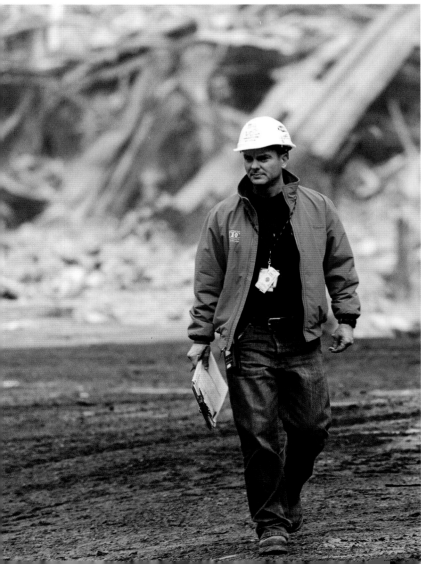

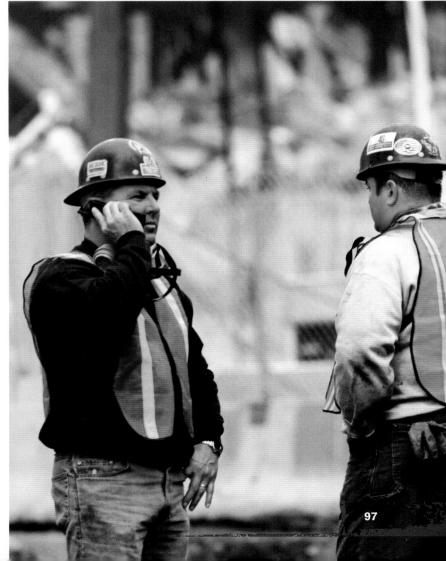

Thank You for all the wonderful things you are doing for New York. You are more than a tremendous help to our country. I am praying for your safety. God Bless America. And God Bless You!

Love,
Samantha G.

9 years old

Our raucous and corruptible political system lumbers on toward a true and universal justice . . .

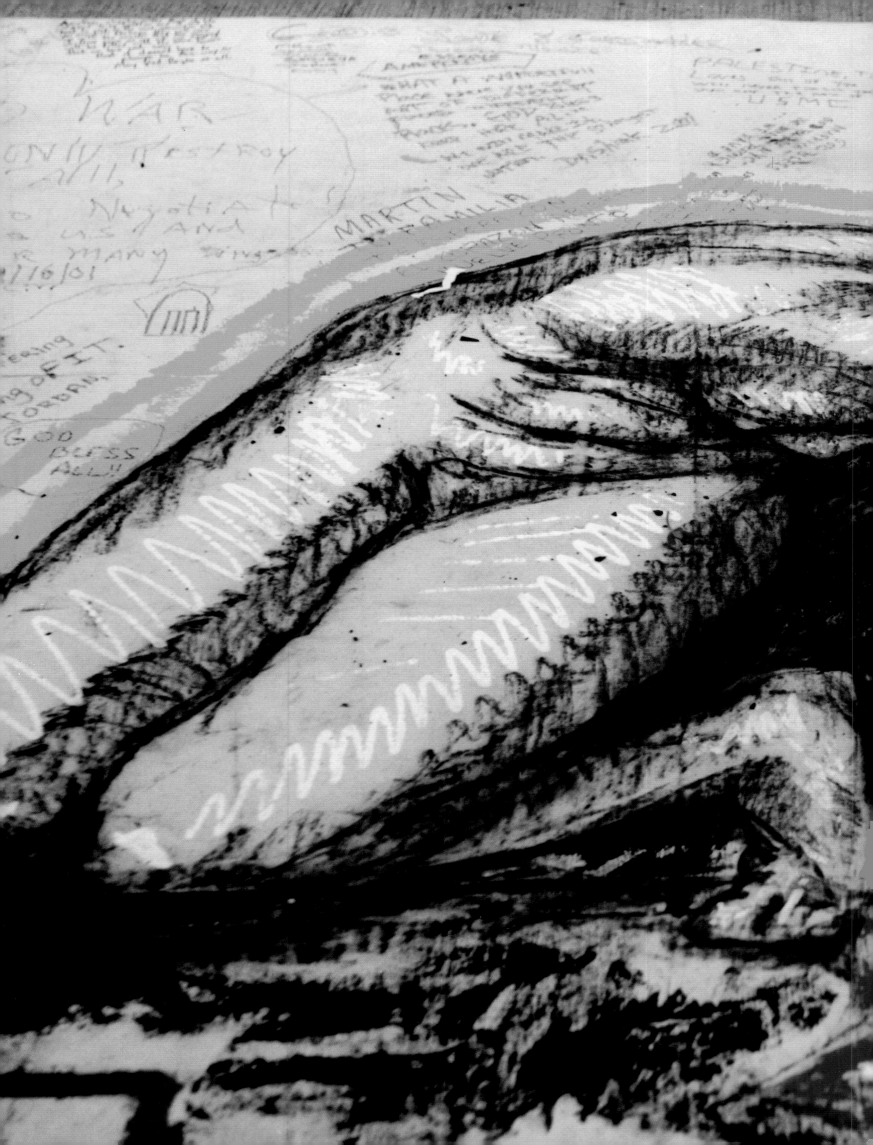

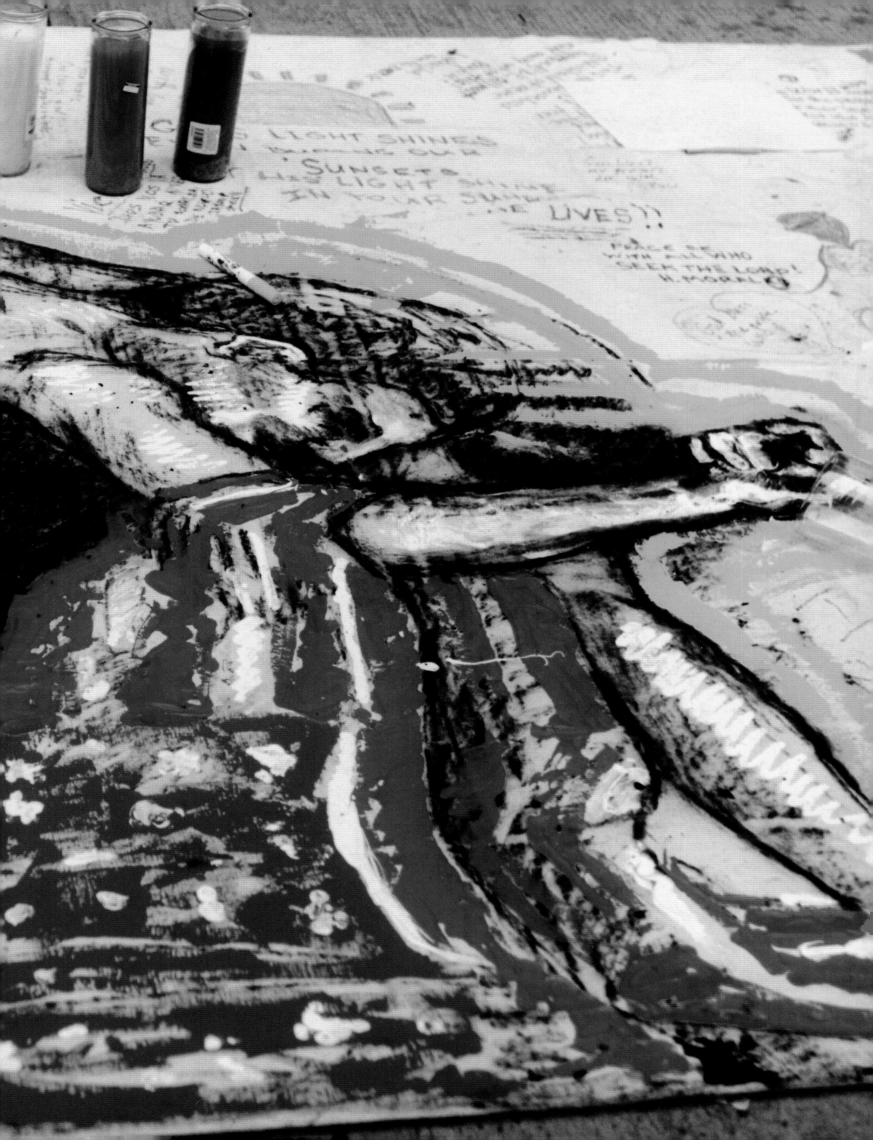

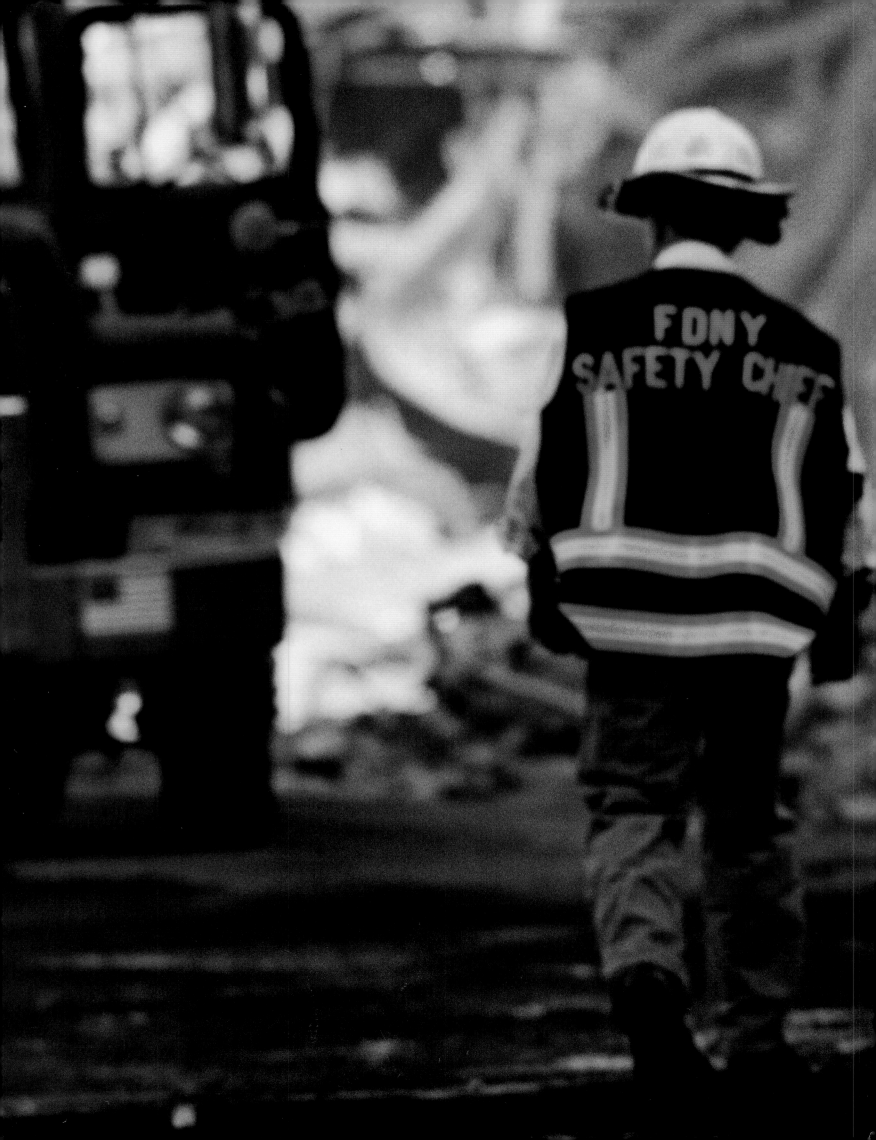

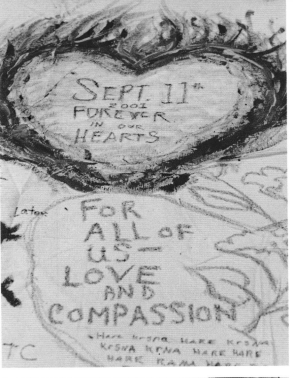

SEPT. 11th
2001
FOREVER
IN OUR
HEARTS

FOR
ALL OF
US—
LOVE
AND
COMPASSION

Hare Krsna Hare Krsna
Krsna Krsna Hare Hare
Hare Rama Hare

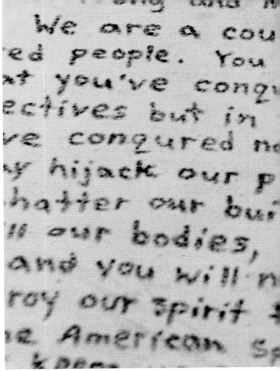

We are a cou
red people. You
at you've conqu
ectives but in
ve conqured n
y hijack our p
hatter our bui
ll our bodies,
and you will n
roy our spirit
he American s

LOVE
is the "ONLY"
ANSWER to ALL
oF the WORLDS
hatred....So LET Us
ALL LOVE ONE
GOD

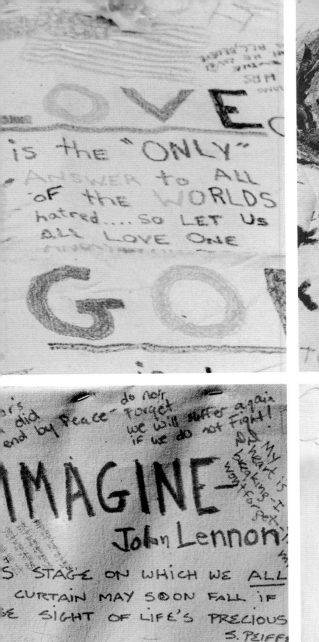

IMAGINE
John Lennon
STAGE ON WHICH WE ALL
CURTAIN MAY SOON FALL IF
SIGHT OF LIFE'S PRECIOUS

did
end by peace- do not
forget
we will suffer again
if we do not fight!

S. PEIFFE
93RD FLO

THE SPECTER FAMILY
PRAYS FOR ALL THE
VICTIMS OF THIS
DISASTER...
ALD AND JANINE
YOU IN

TRACY
PARSLEY

HAVE IS
EACH OTHER.
N PEACE.
Side

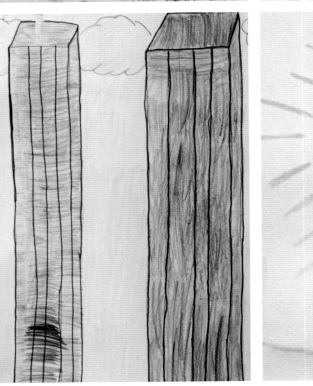

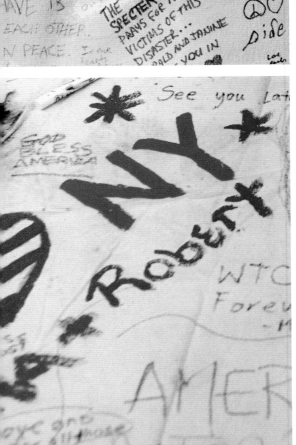

GOD
BLESS
AMERICA

See you Lat

NY
ROBERT

WTC
Forev

AMER

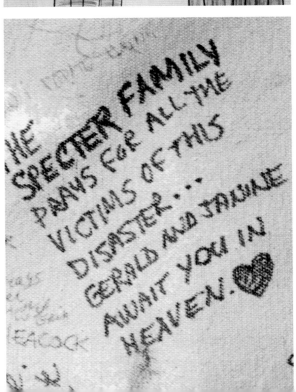

HE SPECTER FAMILY
PRAYS FOR ALL THE
VICTIMS OF THIS
DISASTER...
GERALD AND JANINE
AWAIT YOU IN
HEAVEN.
EACOCK

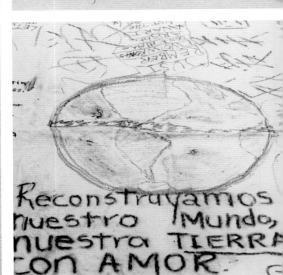

Reconstruyamos
nuestro Mundo,
nuestra TIERRA
con AMOR.

inst

WHAT WOULD
LUTHE

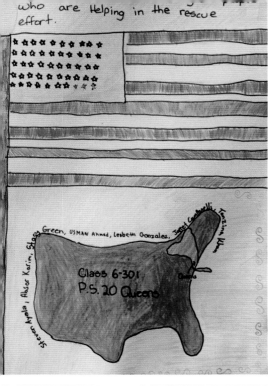

who are Helping in the rescue effort.

Steven Ayala, Aldor Karim, Shaquel Green, USMAN Ahmed, Lesbeth Gonzalez, Imel Gottnelli, Tanzina W.

Class 6-301
P.S. 20 Queens

You Did a Great JOB!

KBW
WTC
98-89

WTC
FOREV...
K...

BELOVED

AMERICA

FOOT Pr...

ONE NIGHT A MAN HAD A DREAM. HE DREAMED HE WAS WALKING ALONG THE BEACH WITH THE LORD. ACROSS THE SKY FLASHED SCENES FROM HIS LIFE. FOR EACH SCENE HE NOTICED TWO SETS OF FOOTPRINTS IN THE SAND; ONE BELONGED TO HIM, AND THE OTHER TO THE LORD.

WHEN THE LAST SCENE OF HIS LIFE FLASHED BEFORE HIM, HE LOOKED BACK AT THE FOOTPRINTS IN THE SAND. HE NOTICED THAT MANY TIMES ALONG THE PATH OF HIS LIFE THER... WAS ONLY ONE SET OF FOOTPRINTS HE ALSO NOTICED THAT IT HAPPENED AT THE VERY LOW... AND SADDEST TIMES IN HIS LIFE.

THIS REALLY BOTHERED HIM AND HE QUESTIONE... THE LORD ABOUT IT. LORD, YOU SAID THAT ONCE I DECIDED TO FOLLOW YOU, YOU'D WAL...

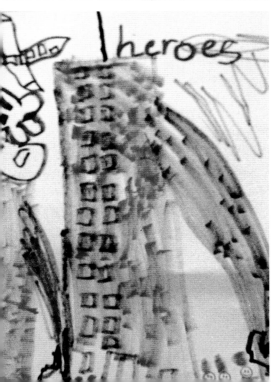

heroes

GOD make u...
instruments ...
THY "PEACE...
Where ...
is Hate...
...We...
...fra...
...into...
...HEROS
FDNY
...GOD BLESS...
...THANK...

Turn around and go back

There is no limit to the variable genius of human
character, the full expression of human capacity . . .

...yed. The beutiful Towers
...longer standing tall.
...s those who lost their lives.
...ose who lost their husbens
...wives. Fathers. mothers.
...ters and sons may their
...remain with the lord above.
...our hearts remain with
...Relatives. friends now
...Hard for us to live on with

PEACE WILL NOT COME OUT OF

...ere be no more suffering
...re crying. no more death.
...for life for breath. May
...be the begining of the end.
...we have a shoulder to lean
...riend. May we keep
...ng eachother caring for
...oneanother
...we be able to be in peace.
...more survivers we

Every Night

No more lives torn apart

That wars will never start

And times will heal our hearts

Everyone will have a friend

And right will always

CLASH OF ARMS BUT OF JUSTICE LIVED.

This is what I pray for

Every Night

Hopeing to never see that Sight

That sight of death

Trying to get Breath

So prey for

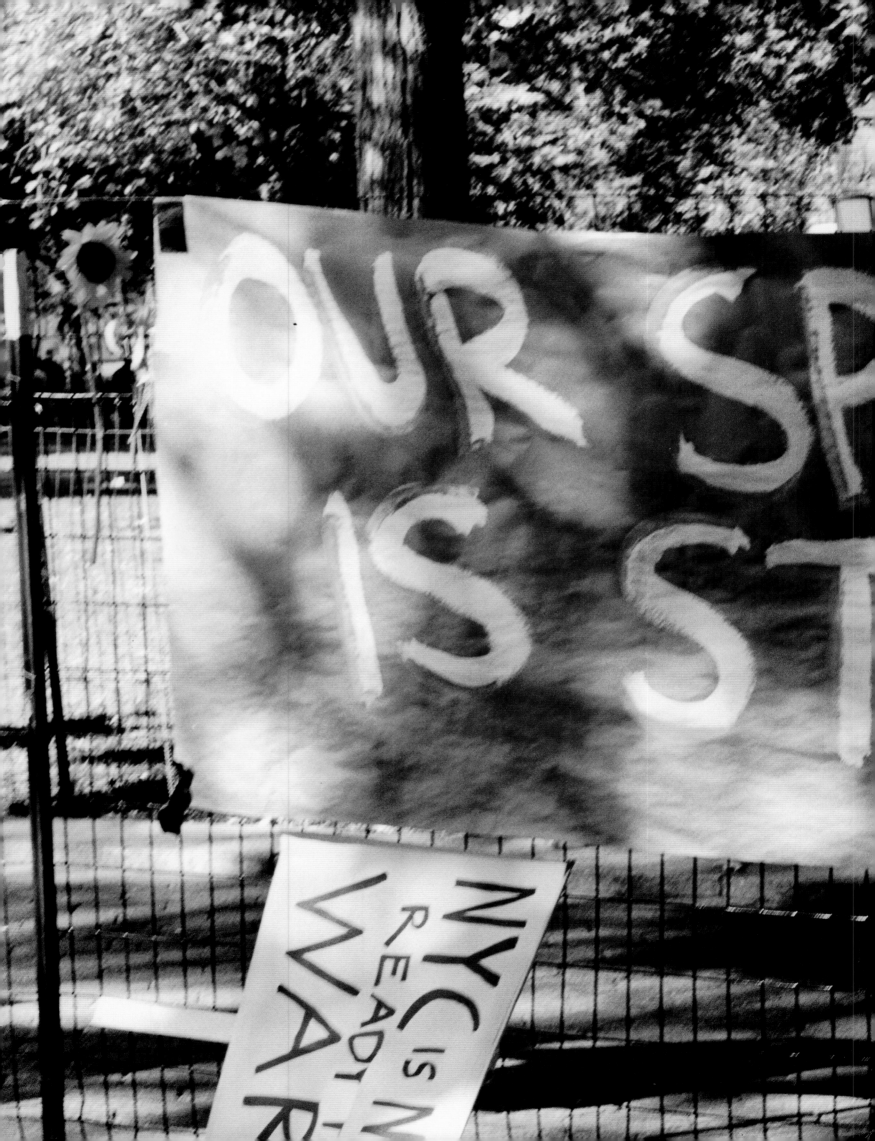

t will report the universe with endless ascription, infinite surprise . . .
and this conviction too we shared, and all of them together comprised
he metropolitan oversoul in which we moved and lived.

Let this serve us together...

Attack on America

It is 8:45, Tuesday, September 11, 2001. A normal day for many commuters, students and workers in that general area. Minutes later, a commercial airliner screamed overhead, altitude dropping sharply. The Boeing 767 Jumbo Jet slams headlong into the upper floors of Tower One of the World Trade Center. Several minutes later, a second plane shattered the middle levels of Tower 2, and within the course of an hour, the most distinguishing characteristics of the New York City Skyline was reduced to rubble. Soon after the Pentagon had been attacked, as were other prime targets.

Mixed feelings entered the hearts of the American people after word of the attack spread. Anger toward who mercilessly slaughtered American victims. Sorrow for the families who lost loved ones to this terrorist tragedy. And strangely, a feeling of triumph, and hope. Triumph, because the terrorists failed. Triumph, because the American people can rebuild. Triumph, because the resolve of the American people will prevail, once again.

Carlo
13 years old
09-12-01

GOD BLESS AMERICA

GOD BLESS AMERICA NEW YORK

GOD BLESS NEW YORK

TO: NEW YORK
BRAVE

NEW YORK CITY TH
YOUR COURAGE AND
IN OUR TIME OF
DAY YOU RISK YOU

YOUR BRAVERY RES
AN ANGEL IN TH
BE VICTIMS TO DE
YOU FALL IN TH
NEW YORK CITY'S
BE KNOWN AS N
ANG

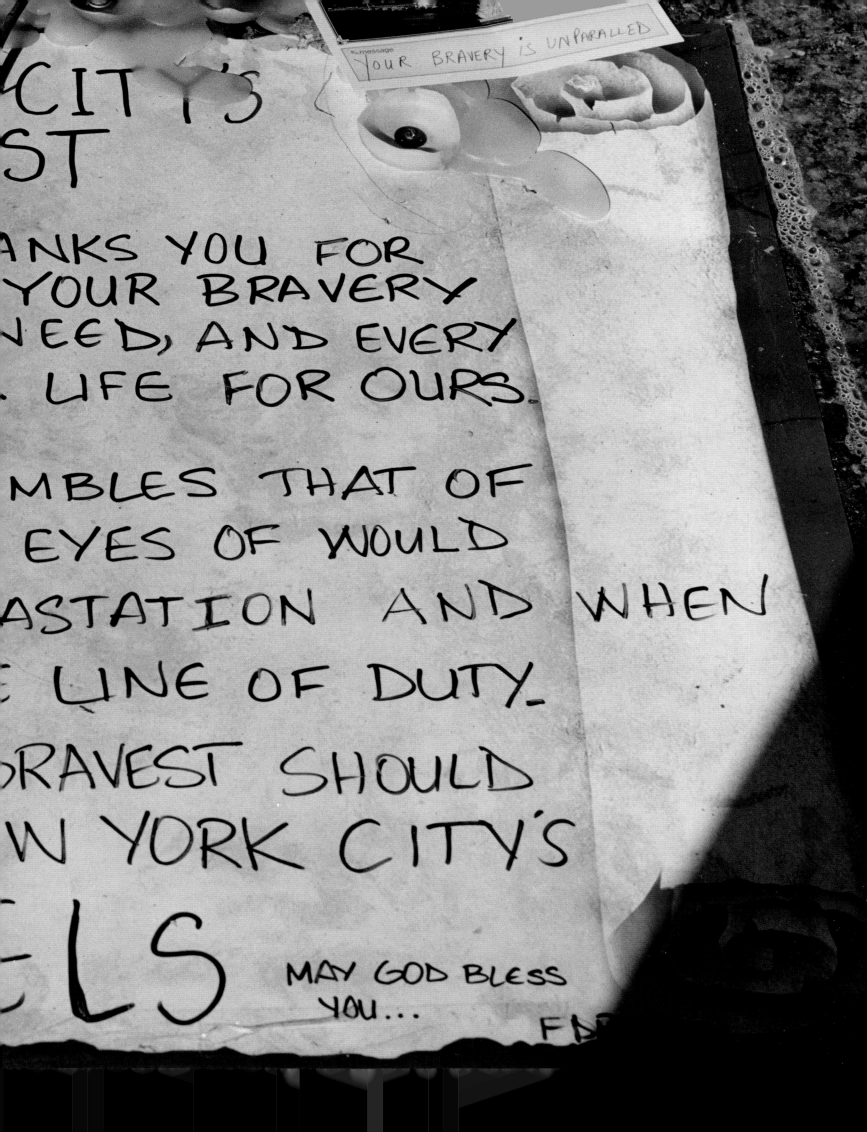

Killer,

when in your malignity, and in the evil illusion of your righteousness, you did this hideous damned thing, our thousands of dead were transfigured, and in their names and numbers they stand now for our Democracy. So that even as we mourn them, we know that they are our endowment, and that the multiplicity of our voices assures the creation of a self-revising, consensual reality that inches forward over generations to an enlightened forbearing relationship among human beings . . .

. . . and a dream of truth.

E. L. DOCTOROW

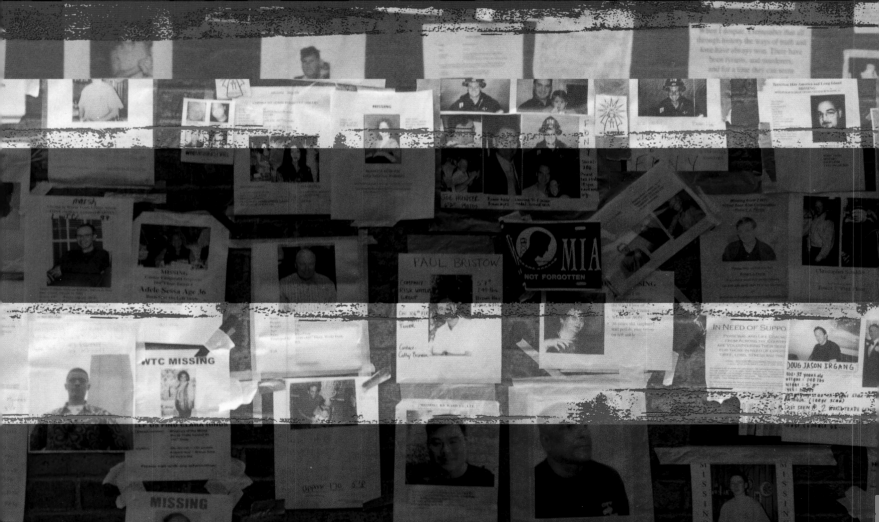